IMAGES OF LONDON

PECKHAM
AND NUNHEAD

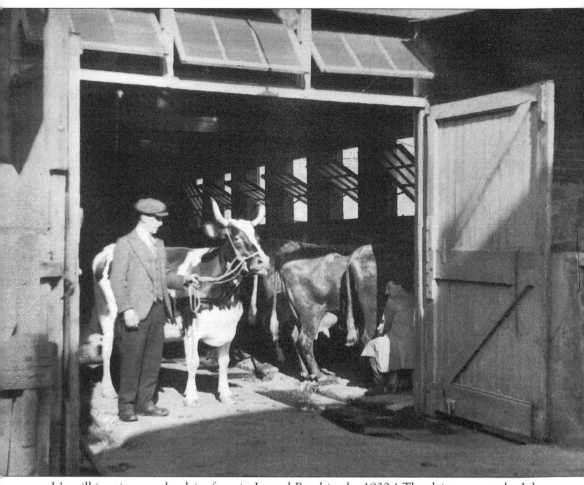

It's milking time on the dairy farm in Lugard Road in the 1930s! The dairy was run by John Jorden who was London's last cowkeeper. He remained in business until 1967.

Front cover: Rye Lane in 1914.

IMAGES OF LONDON

PECKHAM
AND NUNHEAD

JOHN D. BEASLEY

The
History
Press

First published in 1995 by Tempus Publishing Limited
Reprinted 2000, 2003

Reprinted in 2010 by
The History Press
The Mill, Brimscombe Port,
Stroud, Gloucestershire, GL5 2QG
www.thehistorypress.co.uk

British Library Cataloguing in Publication Data.
A catalogue record for this book is available from the British Library.

ISBN 978 0 7524 0122 5

Typesetting and origination by Tempus Publishing Limited
Printed and bound in England

Contents

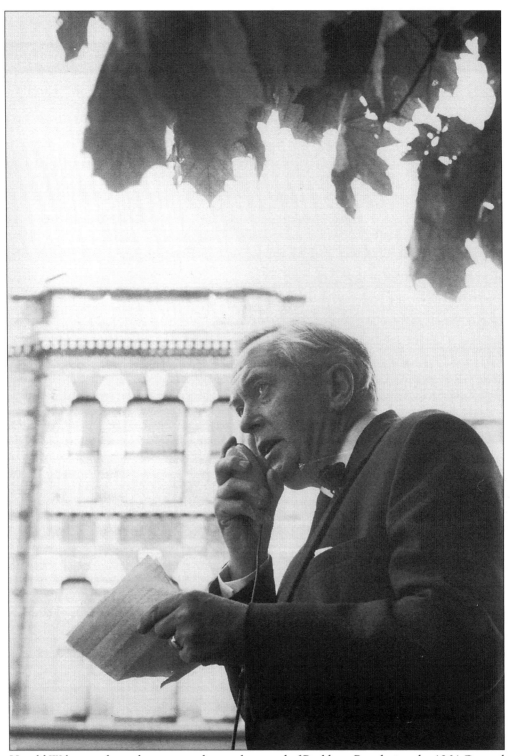

Harold Wilson spoke under a tree at the northern end of Peckham Rye during the 1964 General Election campaign.

6

Introduction

When *Domesday Book* was compiled in the eleventh century, Peckham was known as Pecheham. Peckham Rye is mentioned in fourteenth-century documents.

Peckham grew faster as a Surrey village than Nunhead, which developed slowly from a hamlet. It was not until the Tudor era that there emerged the separate place name of 'Nonehead' which appears on John Rocque's map dated 1741–45.

Peckham had no church until the seventeenth century, when a Nonconformist meeting house was built in what is now Meeting House Lane. The first Anglican church was not erected until over 150 years later.

During the eighteenth century, Oliver Goldsmith was an usher (assistant teacher) at Dr Milner's Academy in what is now Goldsmith Road. The founder of Methodism, John Wesley, stayed in Peckham at least ten times towards the end of his life and began writing his last will while staying there on 8 January 1789. William Blake, when he was eight or ten, walked across fields from his home in the city of London to Peckham Rye and had his first vision – of 'a tree filled with angels, bright angelic wings bespangling every bough like stars'.

In *The Architecture of Peckham* Tim Charlesworth wrote: 'Peckham at the end of the eighteenth century was a picture of rural peace – a few cottages and manor houses dotting the tracks between the fields and market gardens … Peckham, until the turn of the nineteenth century, was a quiet Surrey village of largely agricultural character … The reason for this seclusion was that it was by-passed by the Old Kent Road, and not touched by a through route until Camberwell New Road from Vauxhall Bridge was laid out in 1818.'

In the early part of the nineteenth century there were market gardens and fields but as London's population grew, houses were built on the open spaces. However, William Hone, who lived at Peckham Rye in 1834, described it as

a 'quiet and remote place'. John Ruskin was able to visit a chalk pit in 1847 and his wife described the countryside as 'looking most exquisitely beautiful'. In 1874 James Greenwood in *The Wilds of London* quoted an inhabitant of a central London slum who referred with envy to 'Peckham and them airy parts'.

Houses were built along main roads connecting Peckham with Camberwell and other former villages. Some Georgian houses still exist in Queen's Road.

The arrival of the railway stimulated growth in the area. Peckham Rye Station, opened in 1865, encouraged the development of Rye Lane as a more important shopping centre than the High Street.

The last thirty years of the nineteenth century represented the peak of suburban growth for Peckham and Nunhead which ceased to be in Surrey after the London County Council came into being in 1889.

The shortage of recreational space for the large population was acknowledged by the creation of Peckham Rye Park from Homestall Farm. The park was opened in 1894. St Paul's Cathedral can be seen from the park's main entrance. This is appropriate as two former Deans of the Cathedral had links with Peckham – the poet John Donne, whose second son was born there; and Dr Walter Matthews, who was christened at All Saints' Church, Blenheim Grove, and preached his first sermon there.

During the nineteenth century, Robert Browning attended a boarding school in the High Street; the first editor of the Oxford English Dictionary, Sir James Murray, lived in Denman Road; and Charles Dickens had a secret love affair in Linden Grove.

John Reagan, whose grandson became President Ronald Reagan, was born in Peckham in 1854. Another notable person who was born in Peckham was Mabel Philipson who became the first British-born Conservative woman MP.

Charles Brock ran a firework factory in Nunhead and Alfred Harman had a photographic business in the High Street which developed into Ilford Limited.

Also during the nineteenth century, Oliver Cromwell's skull was owned by a doctor in Queen's Road, Dr Wilkinson.

By the beginning of the twentieth century, the area was packed with Victorian houses. Peckham's population in 1901 was 93,033 (compared with 12,563 in 1841).

The growth in transport facilities enabled local people to travel further afield to work, though many people were employed locally.

In 1904 the first double-decker motor omnibus in the world was run by the Peckham firm Thomas Tilling. Its inaugural trip was from Peckham to Oxford Circus – the same route used by *The Times* horse-drawn omnibus in 1851 on the service started by Thomas Tilling in the year of the Great Exhibition in Hyde Park.

Another transport pioneer who had a link with Peckham was Sir Alan Cobham who flew long distances including to Australia and back in 1926. He received his early education at Talfourd College in Lyndhurst Road (now Way).

An important local pioneering venture was the founding of the blood donor service. A blue plaque on a house opposite Peckham Rye Park, at 5 Colyton Road, records that the founder, Percy Lane Oliver, lived there.

Nearby, in Borland Road, the Gandolfi family had a workshop where they became the only firm left in the world still making wooden handmade cameras. The centenary of the Gandolfi enterprise was marked by a special exhibition at the Science Museum in South Kensington in 1980.

Four doctors made distinctive contributions in the early part of the twentieth century. Dr James Boon broadcast the first sermon by radio in Britain in 1922 and Dr Harold Moody formed the influential League of Coloured Peoples in 1931.

A famous health experiment was started in 1926 by Dr George Scott Williamson and Dr Innes Pearse. A purpose-built centre was erected in 1935 in St Mary's Road for pioneering work in promoting healthy lifestyles. In his book on London, Arthur Mee wrote: 'In setting up this great Health Centre Peckham has set a fine example to the densely peopled areas of our great cities. The West End of London has nothing to equal it.'

Healthy living was also encouraged by the use of Peckham Rye Park for recreation. Travel writer H.V. Morton declared, 'London does not possess a more beautiful park than Peckham Rye.' A plaque in memory of the founder of the London Flower Lovers' League (later The London Children's Flower Society), Alice Street, was added to the park.

Peckham was a thriving shopping centre before the Second World War. Jones & Higgins and Holdron's in Rye Lane were prominent stores which attracted large numbers of customers.

During the Second World War Peckham was pounded by German bombs. Countless buildings were destroyed or damaged and many people were maimed or killed.

Since the war the face of Peckham has changed out of all recognition. Large council estates replaced Victorian streets, particularly north of the High Street and Queen's Road. A seven-year programme to transform north Peckham began in 1995. The decline in Rye Lane as a major shopping centre reflects socio-economic changes that have taken place in the last forty years.

The last link with a bygone era ended when London's last cowkeeper, John Jorden, closed his Lugard Road dairy in 1967. He was a fourth-generation Peckham cowkeeper who kept in business against all odds with a 30-cow to 40-cow herd.

Rye Lane is no longer the Golden Mile but even when it was crowded in the 1950s shoppers were unaware that a Russian spy, Gordon Lonsdale, was working in offices at 163 Rye Lane. The same rooms had previously been used by Tommy Steele for practising guitar playing.

Another notable person who was associated with SE15 was cricketer John Emburey, who played for England and Middlesex. He was born in Meeting House Lane. He attended Peckham Park School and Peckham Manor School.

Television personality Lorraine Chase was 'discovered' in a cafe under the railway arches at Peckham Rye Station; on Saturdays she worked in Jones & Higgins. Actor Jeremy Irons did social work at St Luke's Church on the North Peckham Estate.

Peckham and Nunhead have been birthplace, home and workplace to thousands of people. All who currently live in London SE15 can learn from its fascinating history and make their own positive contribution to the neighbourhood.

In a souvenir programme to mark the unveiling of portraits in the South London Art Gallery of Edwin Jones and George Randell Higgins, founders of the famous Rye Lane store, words of Dante incorrectly attributed to Robert Browning were quoted:

> All men on whom the Higher Nature has stamped the Love of Truth, should especially concern themselves in labouring for posterity, in order that future generations may be enriched by their efforts, as they themselves were made rich by the efforts of generations past.

John D. Beasley
2010

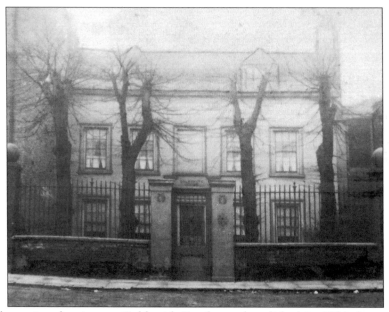

This old house in what is now Goldsmith Road was demolished in 1874. It was here that Oliver Goldsmith became an usher (assistant teacher) in Dr Milner's Academy in about 1756. Goldsmith was unhappy there. He wrote later: 'The usher is generally the laughing-stock of the school. Every trick is played upon him; the oddity of his manners, his dress or his language, is a fund of eternal ridicule; the master himself now and then cannot avoid joining in the laugh; and the poor wretch, resenting his ill-usage, lives in a state of war with all the family.' Goldsmith was probably alluding to his experience as an usher when a character in *The Vicar of Wakefield* said, 'I have been an usher in a boarding school … and … I had rather be an under-turnkey in Newgate.'

One

Pre-Twentieth Century

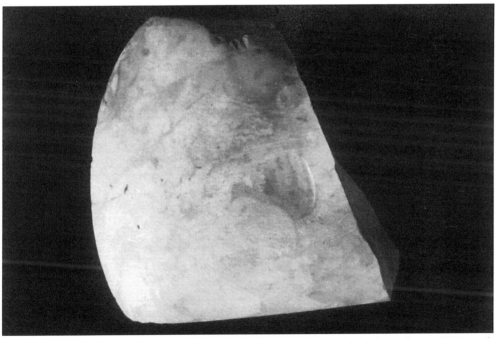

A polished flint axe head dating back to 3000 BC was found in the back garden at 2 Martock Court on the Clifton Estate in 1969. The discovery was made by Victor Goodman.

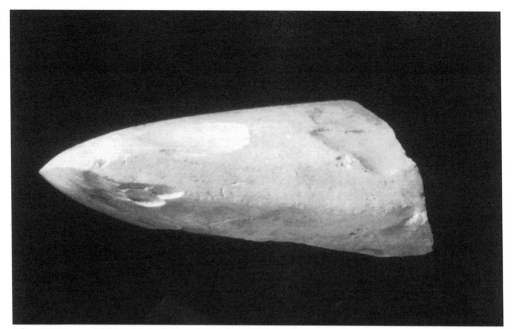

The 5000-year-old axe head found on the Clifton Estate is the only one of its kind to be recorded in this part of the country according to experts at the British Museum. The axe head is stored in Cuming Museum.

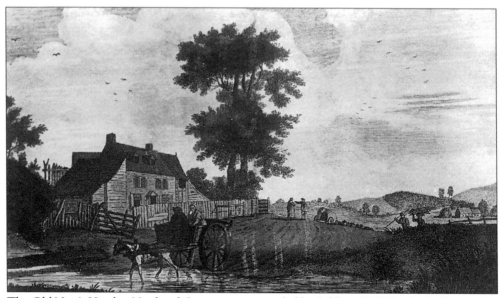

The Old Nun's Head at Nunhead Green was surrounded by fields in 1745. In the background is Nunhead Hill which is 200 feet above sea level.

The Rosemary Branch stood at the corner of what are now Southampton Way and Commercial Way. This 1800 sketch shows the rural nature of Peckham. The grounds surrounding the public house were extensive. Horse racing, cricket, pigeon shooting and all kinds of outdoor sports and pastimes were carried on.

The Rye House on Peckham Rye was painted in 1810.

Cottages stood in what is now Rye Lane in c. 1810.

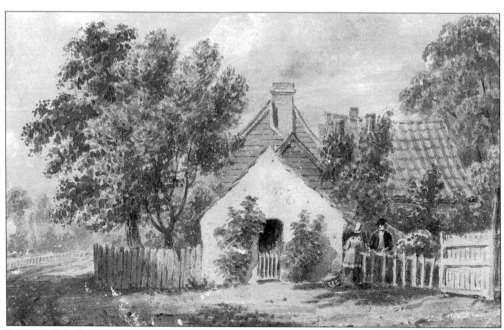

In c. 1815 Gilbart's Cottage stood in what became Rye Lane.

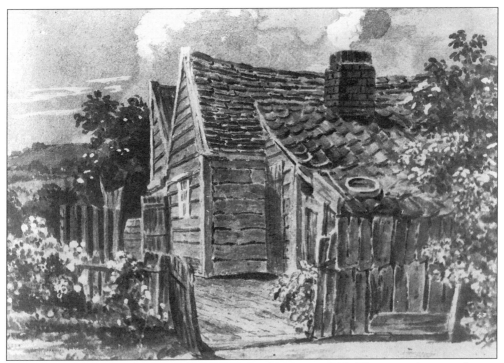

J.B. Cuming painted cottages in what is now Rye Lane in *c.* 1815. The original watercolour is in South London Art Gallery.

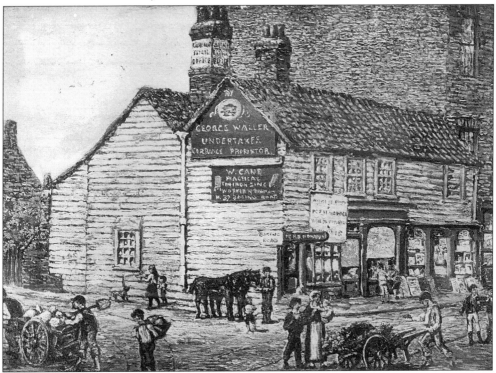

An undertaker had premises in Basing Road (now Bellenden Road) in *c.* 1896.

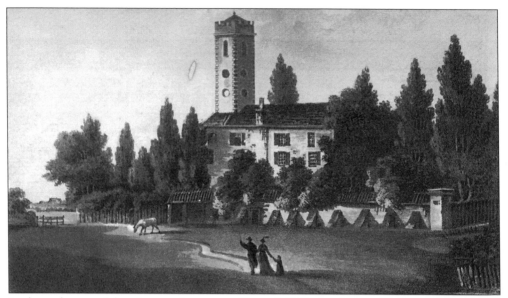

In the early part of the nineteenth century, Heaton's Folly stood between where Hanover Park and the railway line are today. In *Ye Parish of Camerwell*, published in 1875, W.H. Blanch wrote: 'Mr. Heaton, who caused it to be erected, was a very peculiar but well meaning man. He employed a number of frozen out men during a very severe winter in making an immense mound.'

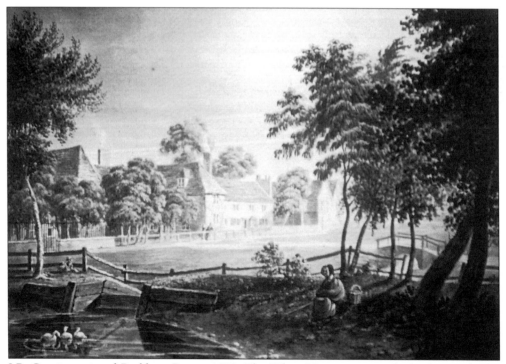

J.B. Cuming painted Peckham Rye in 1828. The White Horse inn is in the background. The original watercolour painting is in South London Art Gallery.

16

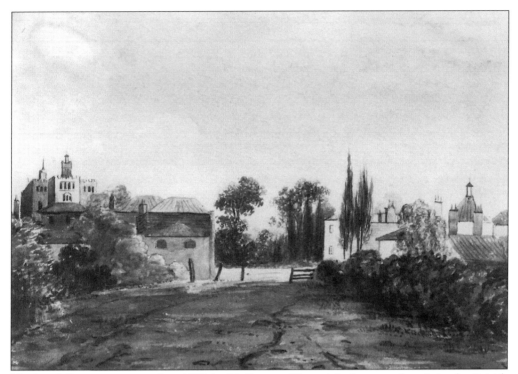

Nunhead Green was painted in 1832 by H. Prosser. The original watercolour is in the British Museum.

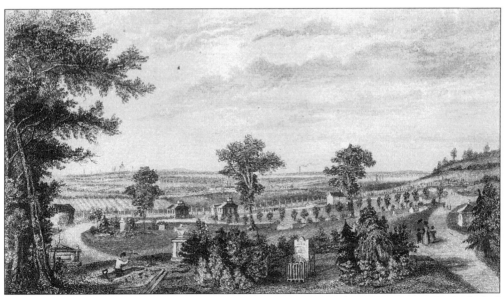

Nunhead Cemetery was surrounded by fields when it was opened in 1840. St. Paul's Cathedral can be seen in the distance.

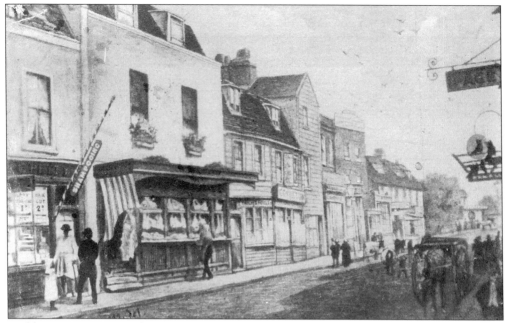

Peckham was in Surrey when the High Street looked like this in c. 1860.

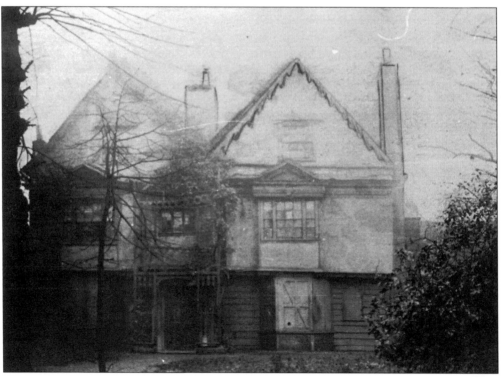

Basing Manor House was photographed on a foggy day a few days before it was demolished on 5 November 1883. The house stood at the corner of what today are Bellenden Road and Peckham High Street.

Two

Housing

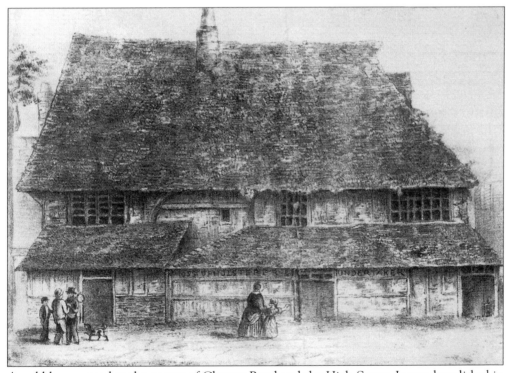

An old house stood at the corner of Clayton Road and the High Street. It was demolished in 1850. Part of the building was used by an upholsterer and undertaker.

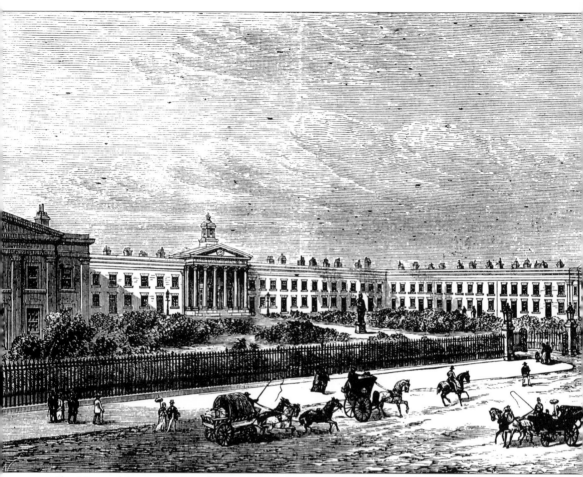

The Licensed Victuallers' Asylum was an impressive building with a chapel in the centre. Now called Caroline Gardens, the building continues to provide accommodation for elderly people. The first stone was laid on 29 May 1828 by His Royal Highness the Duke of Sussex.

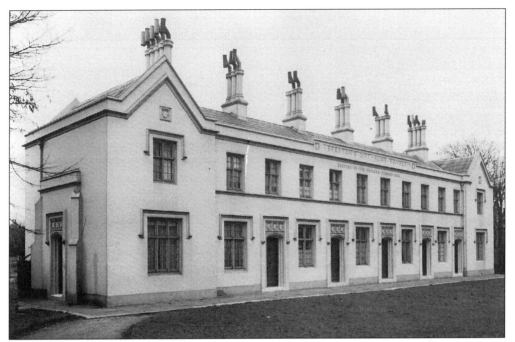

Beeston's Alms Houses were an attractive feature of Consort Road in 1953 (as they are today). They were built by the Girdlers Company in 1834 and named after Cuthbert Beeston, Master of the Worshipful Company of Girdlers in 1570.

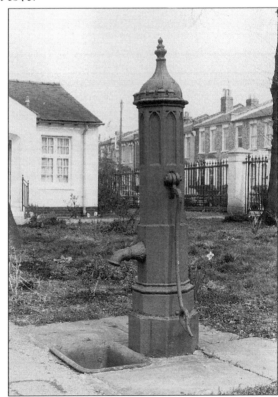

A nineteenth-century Gothic water pump stands in the grounds of Beeston's Alms Houses in Consort Road but it is not in its original position.

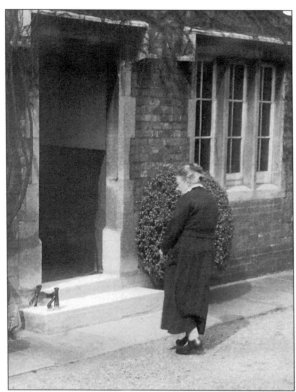

An elderly resident enters the Palyn's Almshouses (now Girdlers Cottages) in Choumert Road. They were built by the Worshipful Company of Girdlers in 1851.

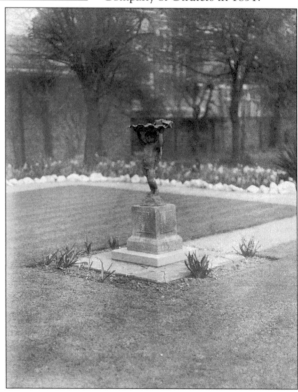

A bird bath stood in the communal garden of Palyn's Almshouses.

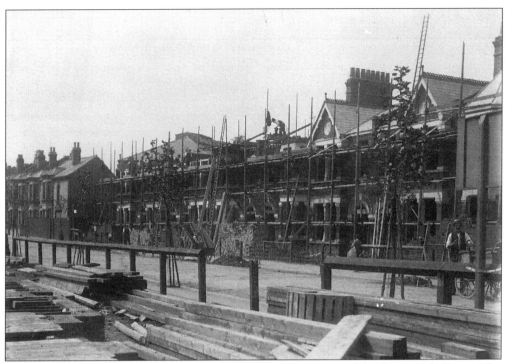

Houses under construction in Copleston Road in 1903 were part of the Grove Vale Estate. The 7 houses and 174 self-contained flats on this estate were the first to be built by Camberwell Borough Council. Plaques outside 106 and 129B Copleston Road record this historic event.

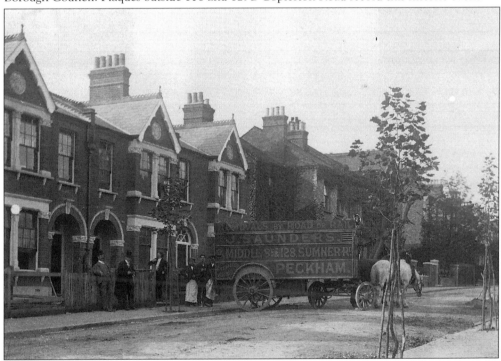

A removal cart is seen outside a new house in Copleston Road in 1903.

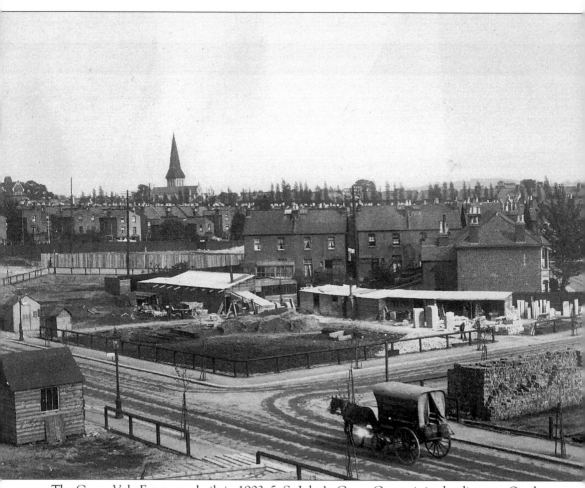

The Grove Vale Estate was built in 1903–5. St John's, Goose Green, is in the distance. On the right is Normanton Terrace (now 1–11 Everthorpe Road).

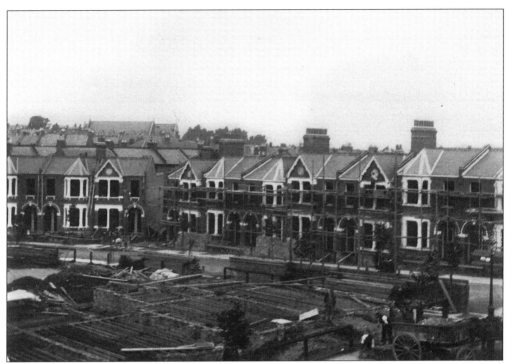
Oxenford Street was built in 1903. St Saviour's Church (now the Copleston Centre) can be seen above the rooftops.

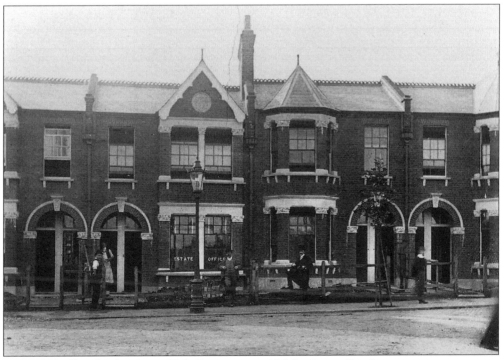
The estate office for the Grove Vale Estate was at 116 Copleston Road.

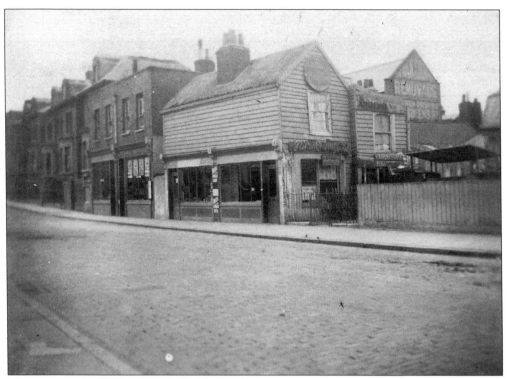

There was no traffic to obscure the view of cottages near the junction of Peckham Rye and Philip Road in c. 1910.

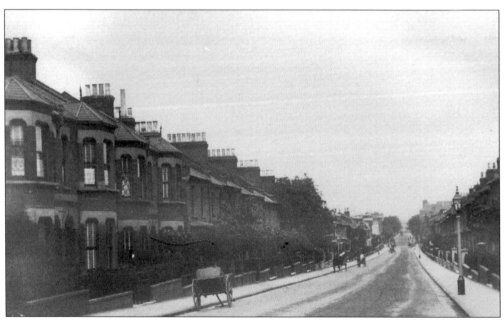

Choumert Road at the beginning of the twentieth century was a quiet residential street lined with Victorian terraced houses.

Troy Town, which is a Cornish expression for a labyrinth of streets, is seen here in 1905.

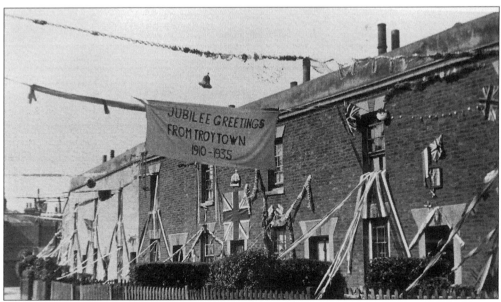

JUBILEE GREETINGS
FROM TROY TOWN
1910 - 1935

The 25th anniversary of George V's accession was celebrated in Troy Town in 1935.

Copleston Road was lined with trees in 1926.

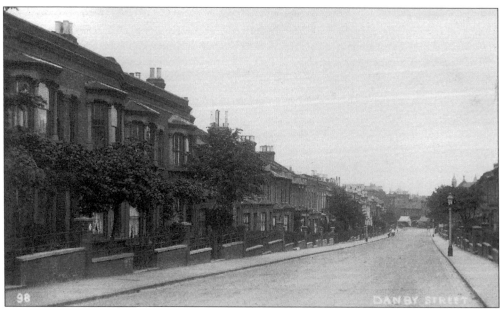

A postcard showing Danby Street was published early in the twentieth century. The top of Bellenden Road United Methodist Church (which later became Hanover Chapel and is now Faith Chapel) can be seen in the distance on the right.

A postcard showing Hollydale Road was published in the early part of the twentieth century. Lugard Road is on the right. Hollydale Tavern (now Hollydales) on the corner of Brayards Road is in the distance.

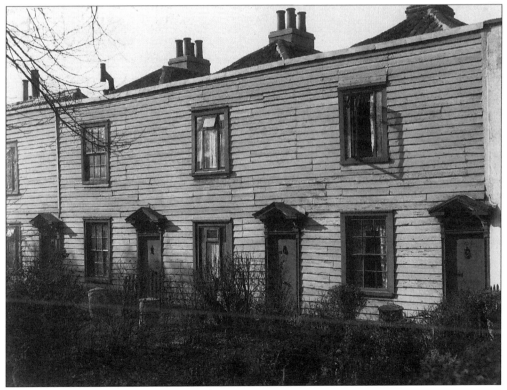

Wooden houses stood in Consort Road in 1953.

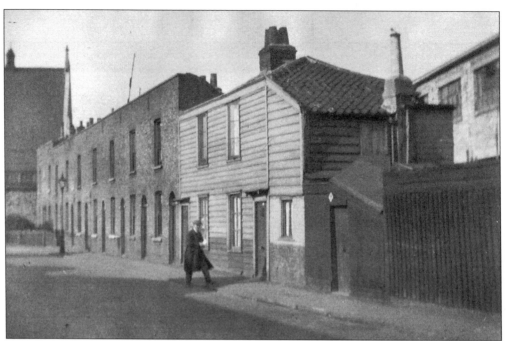

Wooden cottages stood in Harder's Road (now Wood's Road) in c. 1918. Peckham Wesleyan Church is in the background on the left.

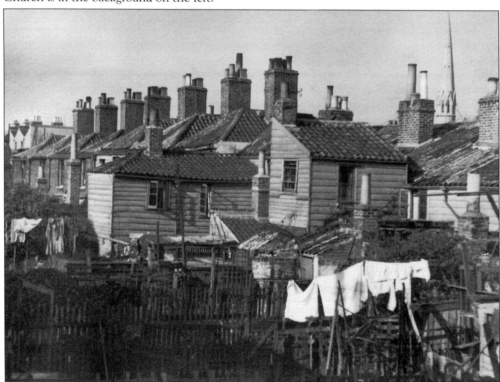

Timber houses in Harder's Road are seen here from the rear. The spire of Peckham Wesleyan Church is in the background on the right.

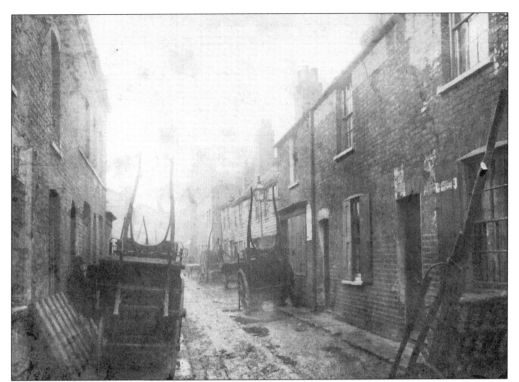

Handcarts were parked on the narrow pavements in Blue Anchor Lane, off the High Street near the Post Office.

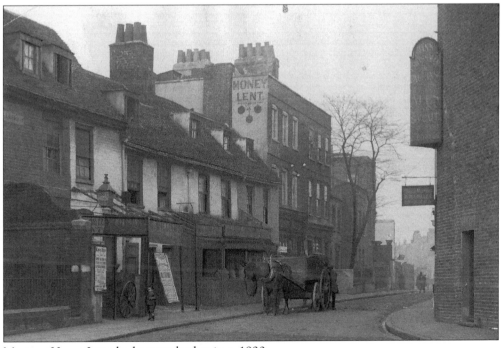

Meeting House Lane had a pawnbroker in c. 1920.

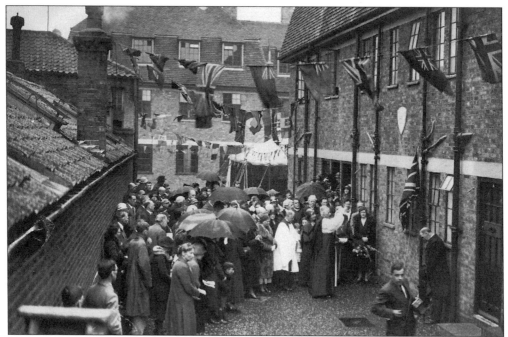

A Church Army housing estate was opened in Bellenden Road on 9 May 1933. Four new blocks of flats were opened by Princess Arthur of Connaught. She was received by Prebendary Wilson Carlile, founder of the Church Army, and Lord Daryngton, its president. She was introduced to the Bishop of Southwark (Dr Parsons), the Mayor and Mayoress of Camberwell (Councillor and Mrs J.A. Garner), Lord Borodale, MP for Peckham, and Canon H.G. Veazey, Rural Dean of Camberwell.

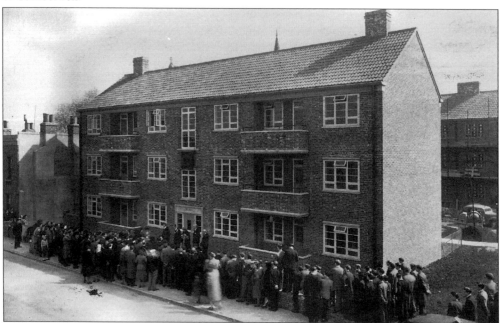

Alder House in Alder Street was opened on 22 April 1950 by the Mayor of Camberwell, Alderman A.F. Crossman.

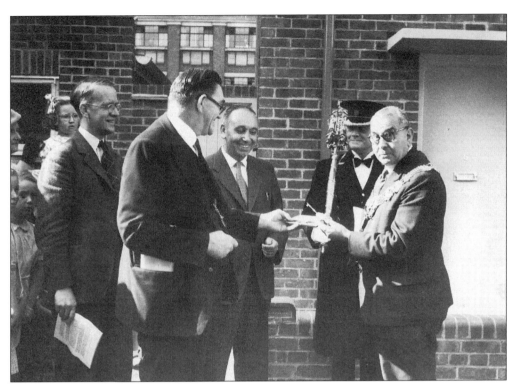

New houses were opened in Parkstone Road on 30 July 1952. The Mayor of Camberwell, Councillor C.A.G. Manning, is holding a key. Alderman Burden, on the left, holds a paper.

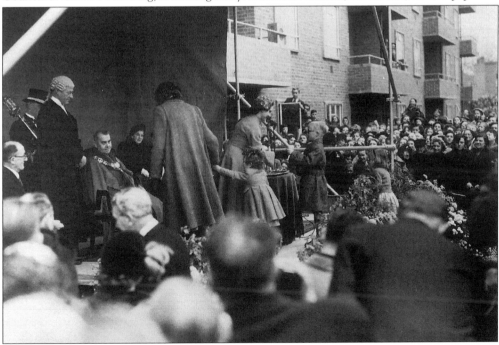

Princess Margaret opened flats for elderly people in Troy Town on 21 October 1952. The flats were built for Camberwell Housing Society.

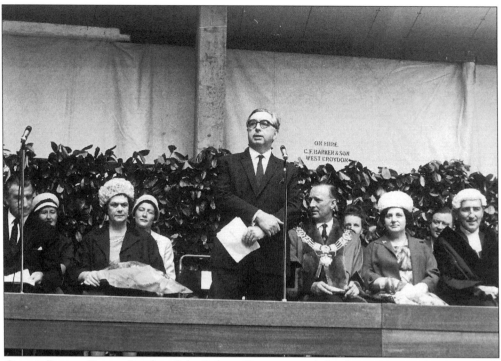

George Brown, Deputy Leader of the Labour Party, opened the Acorn Estate. On the right is the Mayor of Camberwell, Councillor Harry Lamborn, who became MP for Peckham.

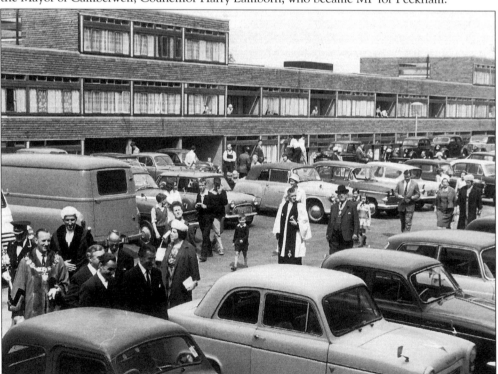

Acorn Estate, in Queen's Road, was opened on 20 July 1963.

Dundas Road had two rows of prefabs.

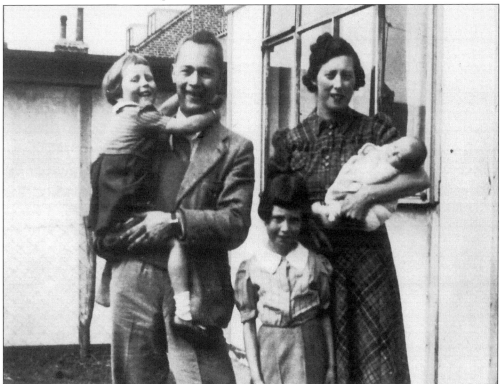

Frederick and Doris Buckle, with their children, lived in a prefab at 135 Kirkwood Road in 1947. They moved there the previous year after Fred had returned from serving in the 14th Army in the Far East. Baby Muriel was born in the prefab in March 1947. Her older sisters Eileen and Margaret were born in April 1940 and May 1943 respectively. The prefab was moved to the Imperial War Museum to be included in the London at War 1939–1945 exhibition beginning in March 1995.

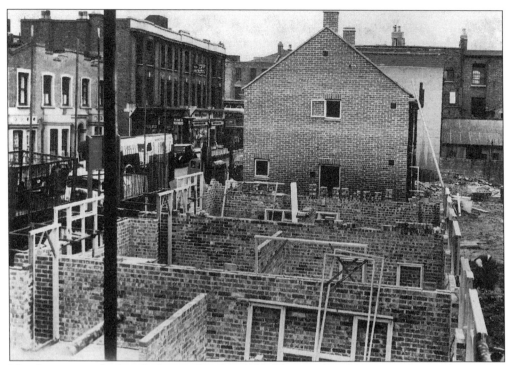

New houses were built in Parkstone Road in 1952. These replaced Victorian houses damaged in the Second World War.

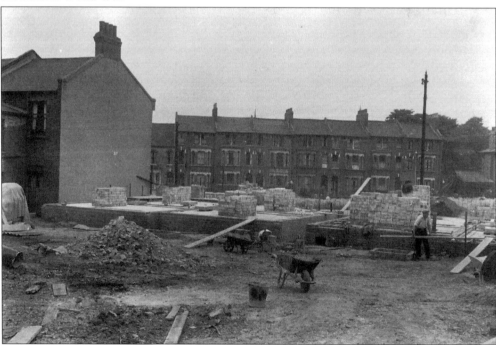

Houses were built in Avondale Rise in 1952. In the background is Bellenden Road. The new houses were erected where Victorian houses and Avondale Road Unitarian Church stood until they were bombed on 11 May 1941.

Three

Shops

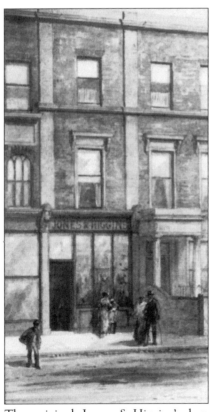

The original Jones & Higgins' shop
opened in 1867 at number 3 Rye Lane.

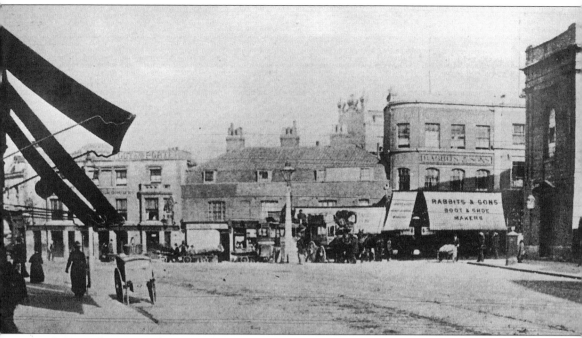

A horse-drawn omnibus stands in the centre of Peckham in 1889. The shop on the right of Rabbits & Sons is Jones & Higgins, linen drapers. The building on the far right is Hanover Chapel.

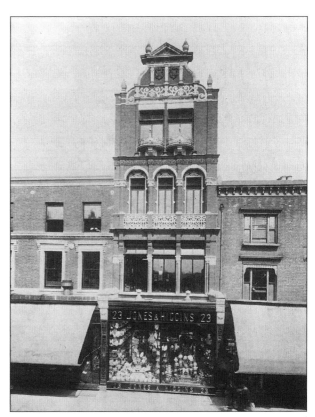

Jones & Higgins added number 23
Rye Lane to their shops in 1891.

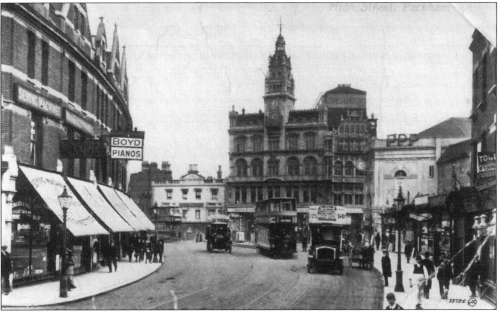

The tower of Jones & Higgins' departmental store dominated the centre of Peckham in the early
part of the twentieth century. The popularity of piano playing is apparent from the two signs
above the High Street shops on the left. On the other side of the road is PPP (Peckham Picture
Playhouse) which used the former Hanover Chapel.

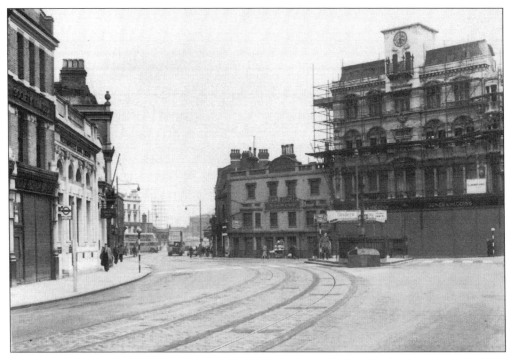

The tower of Jones & Higgins' store was rebuilt after the original one was damaged during the Second World War. The Kentish Drovers public house is on the left.

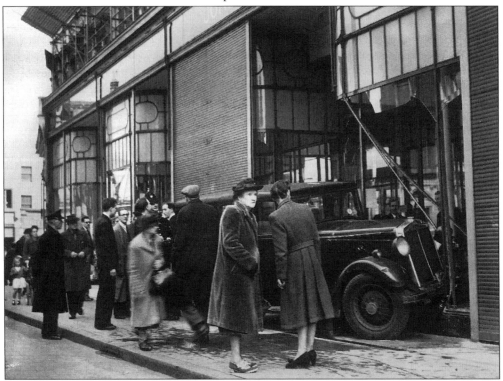

In 1951 a car crashed into Jones & Higgins' window containing Festival of Britain prizes.

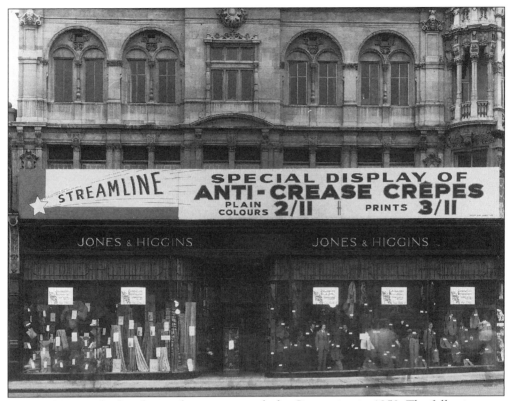

Jones & Higgins displayed special posters to mark the Coronation in 1953. The following year the firm was taken over by Great Universal Stores.

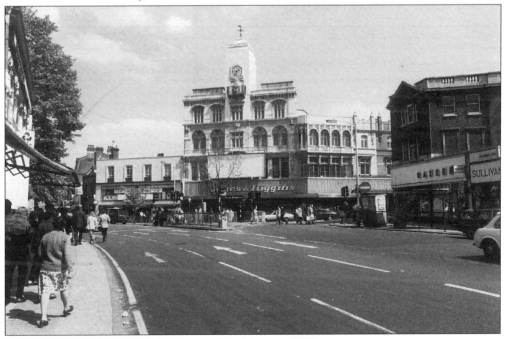

Jones & Higgins dominated the centre of Peckham in 1979.

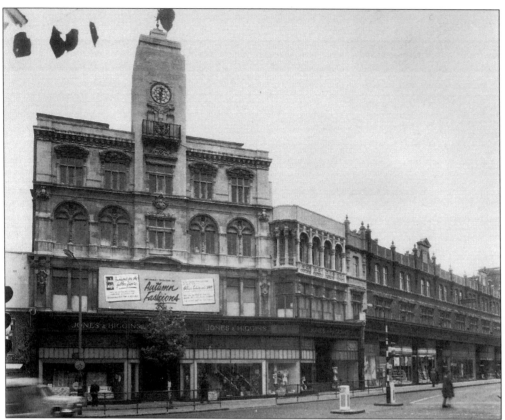

Jones & Higgins was Peckham's main store in 1963. It closed on 7 June 1980 and reopened two days later as The Houndsditch in Peckham. Most of the building was demolished in 1985 and the Aylesham Centre was built on the site.

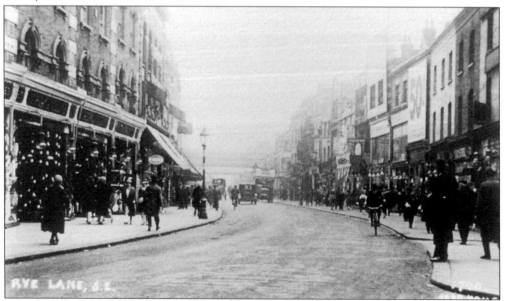

Morgan & Collins, fancy drapers, had a shop on the east (left) side of Rye Lane.

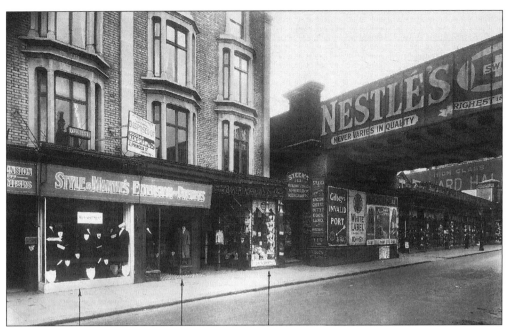

Style & Mantle's and Baker & Norman occupied 107–109 and 113 Rye Lane in the 1920s. A Tower Cinema advertisement shows that a Charlie Chaplin film was being shown. Between the railway lines Holdron's had a shop.

Street lighting was improved in Rye Lane in the 1930s.

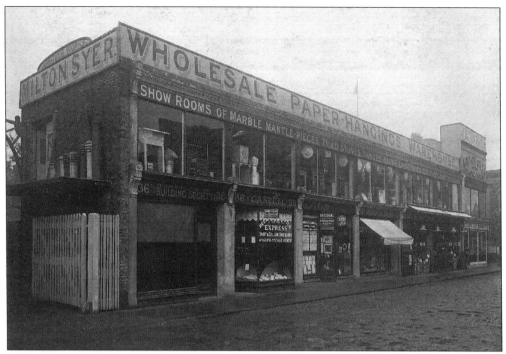

Milton Syer had large premises at the corner of Rye Lane and Hanover Street (now Highshore Road). The firm closed in August 1971. Rye Lane Chapel is on the right.

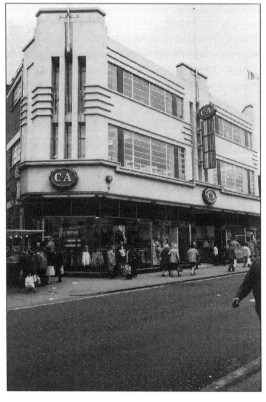

C & A had a large store in Rye Lane in 1981. It closed in February 1987.

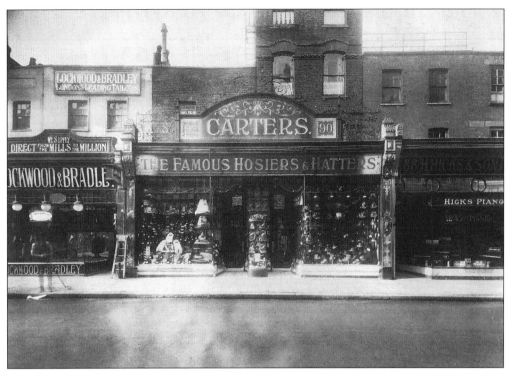

Carters had a shop at 90–92 Rye Lane in the 1930s.

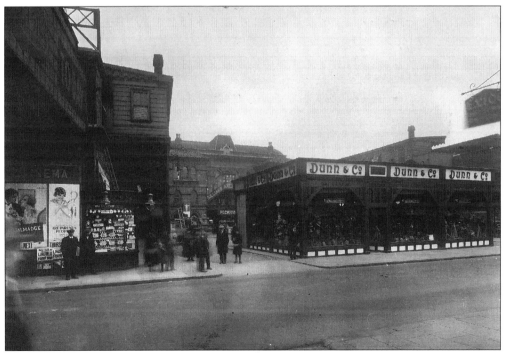

Peckham Rye Station was hidden by Dunn and Company's men's outfitter's shop in the late 1920s. Note the Billiard Hall in the station.

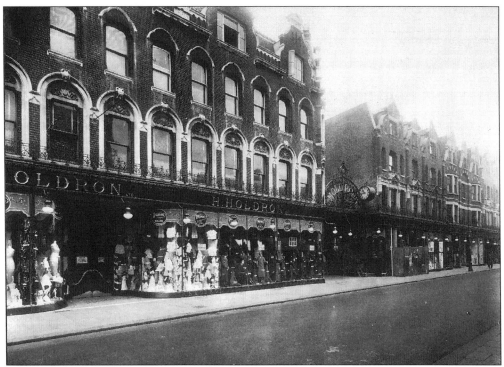

Holdron's was a major store in Rye Lane in the 1920s. The firm began in about 1882 when Henry Holdron's 'Market' opened at 53 Rye Lane. The store closed in January 1949.

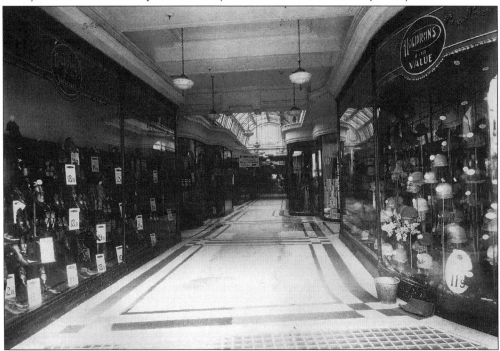

Holdron's Arcade was an ornate feature of this large Rye Lane store in the 1920s.

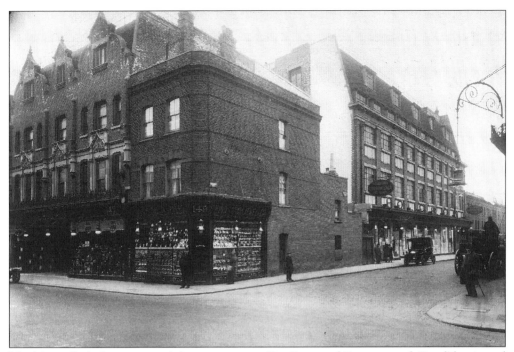

Hinds' jeweller's shop occupied the corner site in Rye Lane and Bournemouth Road dominated by Holdron's in the 1920s. Note the horse-drawn cab on the right.

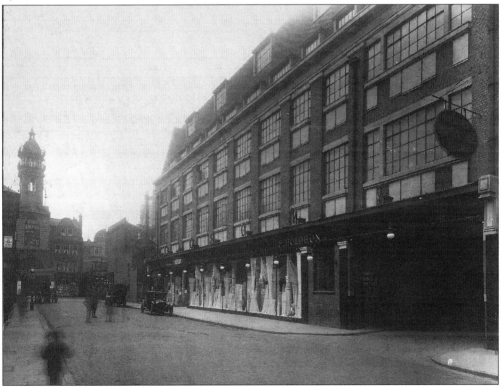

Holdron's store extended into Bournemouth Road and was close to the Tower Cinema.

The rear yard of H. Holdron was quiet on this day in *c.* 1930. The lower part of the chimney still exists and has RONS on it.

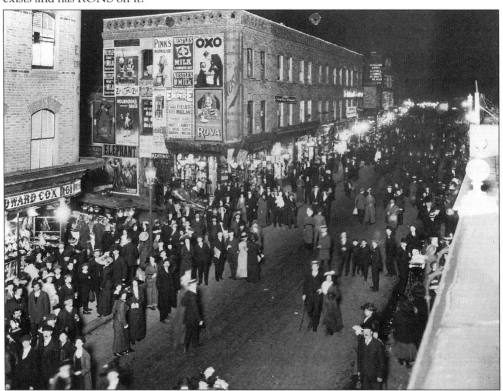

Rye Lane was crowded one evening in 1913. Edward Cox at 161 Rye Lane was a pork butcher. On the wall in Parkstone Road is a poster advertising Houdini at New Cross Empire.

Lipton's opened a shop at 98 Rye Lane in 1891.

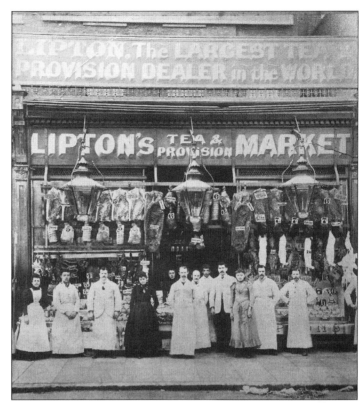

Rye Lane was crowded in the early evening in 1913. Home and Colonial grocer's shop is on the right.

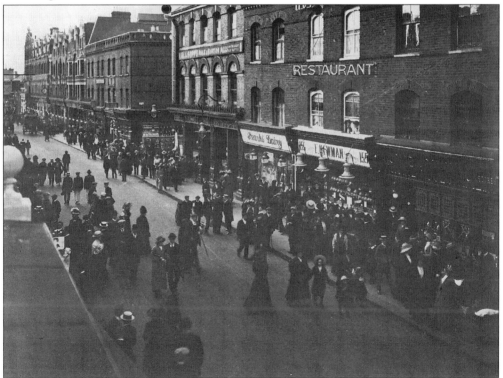

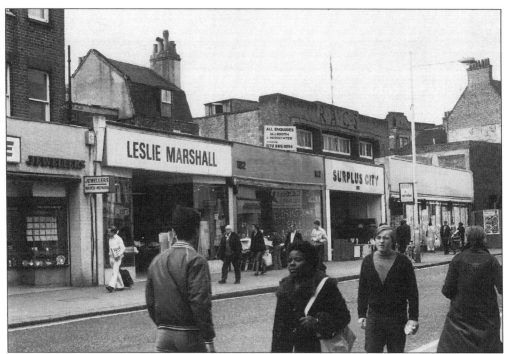

Leslie Marshall's curtain shop existed in Rye Lane in 1981. Note the top of an old house behind the shop and the former Royal Arsenal Co-operative Society shop on the right.

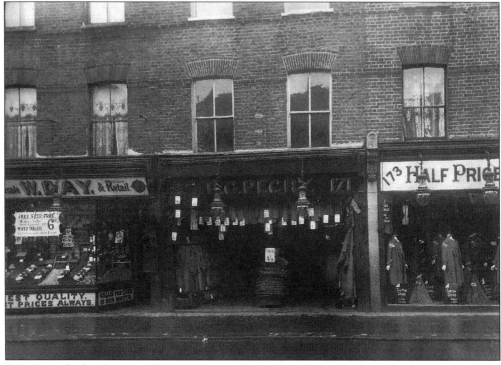

P.G. Pecry had a shop at 171 Rye Lane in the 1930s. Notice the huge lanterns over all the shopfronts.

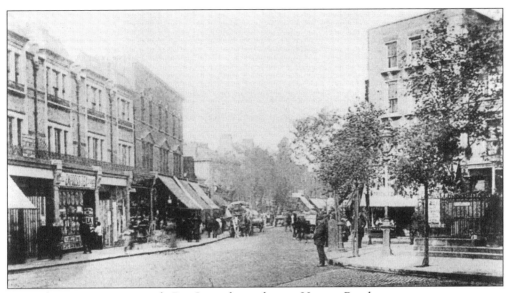

Horse-drawn carts wait outside Rye Lane shops close to Heaton Road.

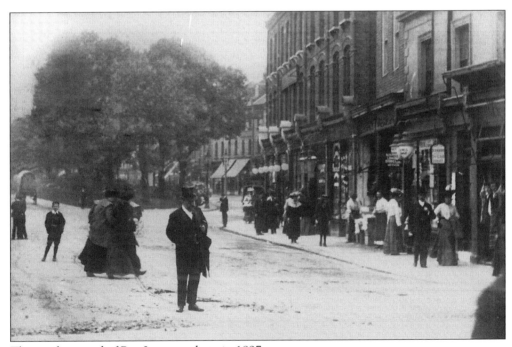

The southern end of Rye Lane was busy in 1897.

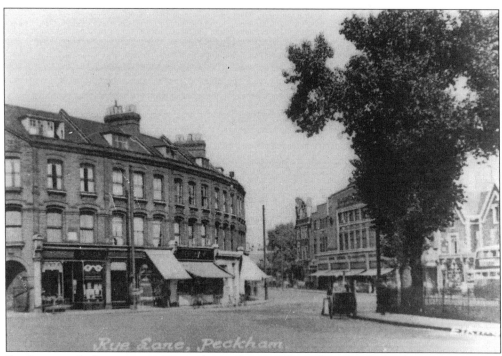

Rye Lane, with Co-operative House (opened in 1932) on the right, had only one bus in view when this picture was taken.

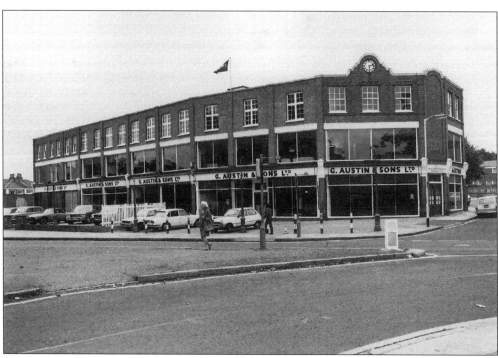

Austin's was the largest store in Peckham Rye in 1981. The firm closed on 5 November 1994. Austins Court now occupies the site.

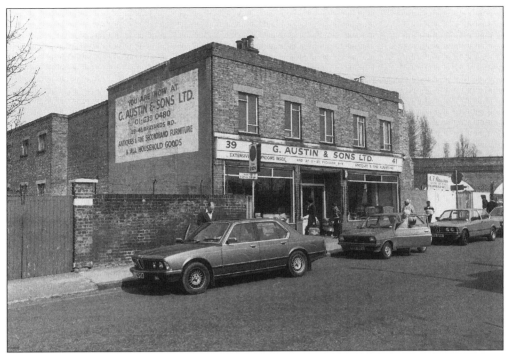

Austin's had premises in Brayards Road in 1982.

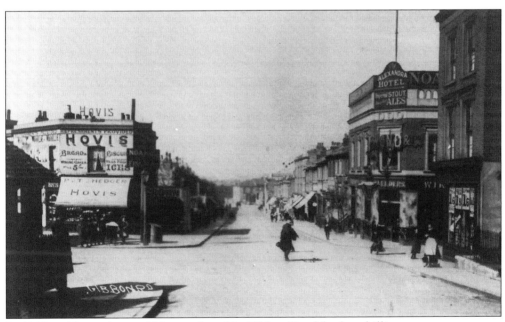

In 1912 wedding cakes could be purchased in Gibbon Road for five shillings.

Shoes were sold and repaired at 56 Victoria Road (now 73 Bellenden Road) in c. 1910.

Shoe repairs were done at 56 Victoria Road in c. 1930. Ellen and William Pailthorpe are standing in the doorway.

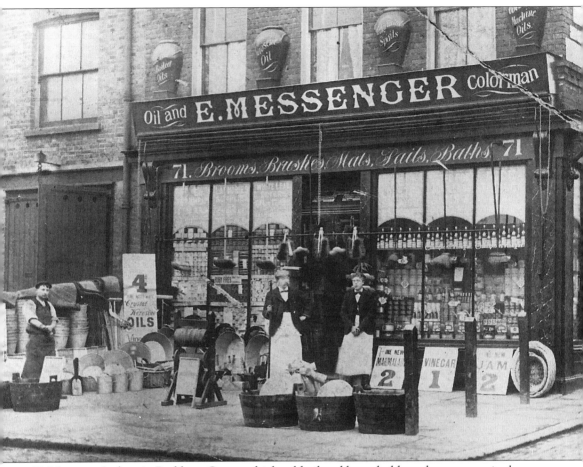

E. Messenger's shop in Peckham Grove, which sold oil and household goods, was on a site later occupied by the packing department of Samuel Jones' gummed paper factory. This picture was taken c. 1900.

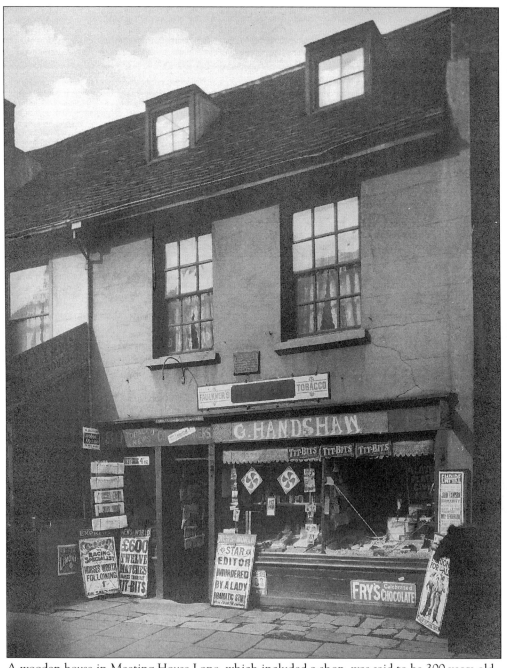

A wooden house in Meeting House Lane, which included a shop, was said to be 300 years old.

Numbers 2, 4 and 6 High Street were
where Bryanston House is today.
Number 6 (on the left) belonged to
George Foy, wholesale haberdasher.

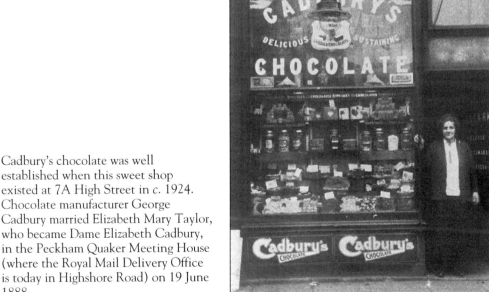

Cadbury's chocolate was well
established when this sweet shop
existed at 7A High Street in c. 1924.
Chocolate manufacturer George
Cadbury married Elizabeth Mary Taylor,
who became Dame Elizabeth Cadbury,
in the Peckham Quaker Meeting House
(where the Royal Mail Delivery Office
is today in Highshore Road) on 19 June
1888.

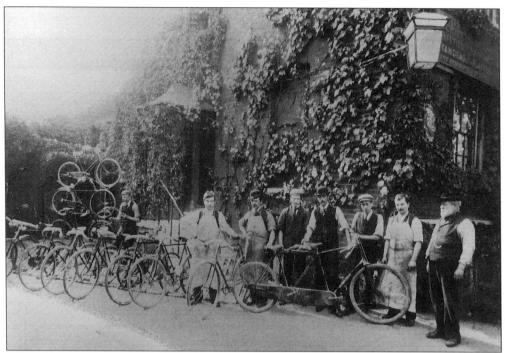

Wilson's cycle firm began in Hill Street in *c.* 1870 but the date of this photograph is unknown.

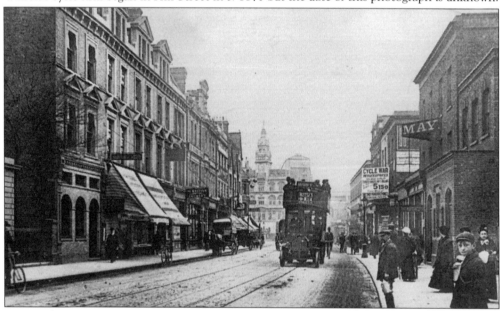

A motor bus trundles past High Street shops in *c.* 1906. The 'Cycle War' poster is above Wilson's cycle shop which opened in the High Street in 1882 and has traded from the same shop ever since. The firm began in Hill Street. The firm's founder was Harold Wilson who traded under the name of H. Wilson & Son. The firm's name was changed to A.E. Wilson by the son of the founder. The shop in the High Street was taken over by A.E. Wilson's son, Norman Arthur Wilson, who ran the cycle shop until shortly before he died aged 91 on 1 April 1995. Wilson's is now the oldest Peckham firm still in existence.

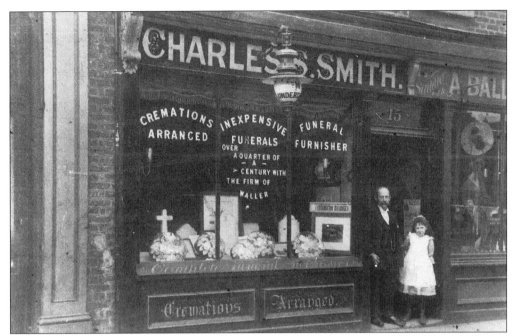

Undertaker Charles Smith stands in the doorway of his premises at 15 Queen's Road in c. 1907 accompanied by his niece Lilian Tandy. The shop was opposite where 4 Queen's Road is today.

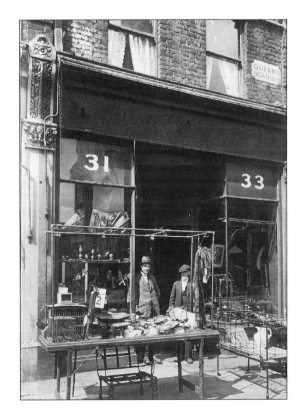

Numbers 31 and 33 Queen's Road were a second-hand shop in the 1920s. Sid Bonson (left) and Dick Dryden are standing outside.

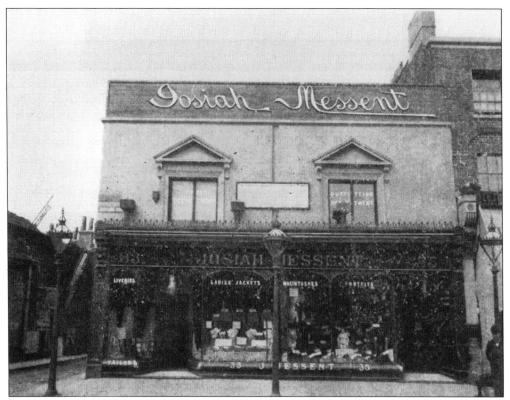

Josiah Messent, Merchant Tailor and Outfitter established in 1846, had a shop at 33–35 Queen's Road in 1892. Part of Acorn Estate later occupied the site. The shop was opposite where the Cherry Tree Court garden at the corner of Wood's Road is today.

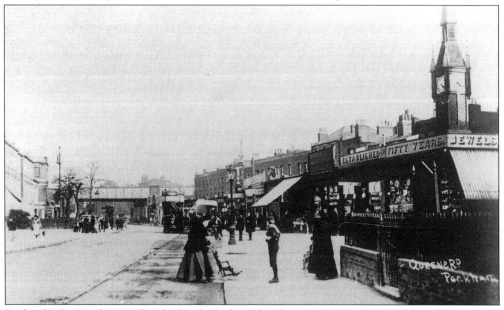

Richard John Wade, jeweller, had a clock above his shop at 82 Queen's Road (on the corner of Burchell Road).

Four

Work

Howard Heinz joined the staff of the Peckham factory for a photograph in June 1922. Howard Heinz, in the centre of the picture, took over running the family firm when his father died in 1919. H.J. Heinz's first factory in England was in Peckham. The firm bought the old-established pickle manufacturers, Batty and Company of 127 Brayards Road. The premises included a number of railway arches; seventeen were used for storage.

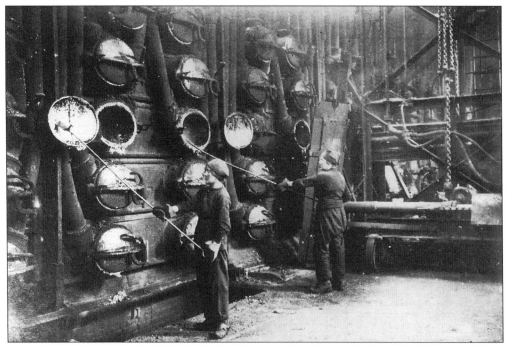

Women are fuelling the retorts in the South Metropolitan Gas Works in the Old Kent Road during the First World War. While men were abroad fighting in the war, 3000 women worked there. Putting fuel in the retorts was a very hot and backbreaking job.

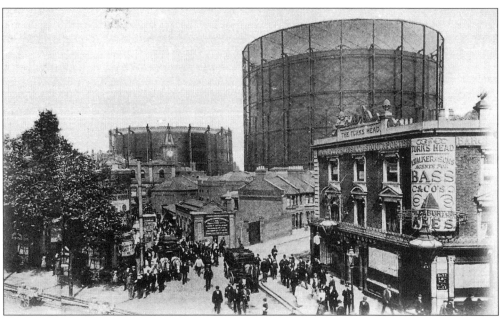

South Metropolitan Gas Works in the Old Kent Road provided employment for many local people. The works began producing coal gas in 1833.

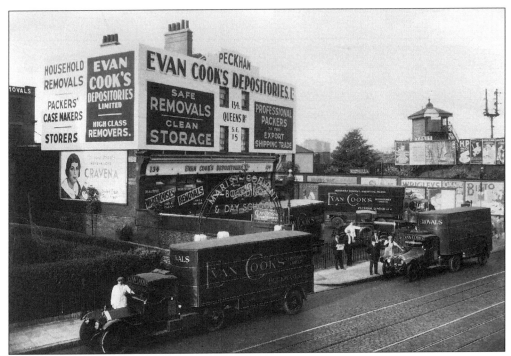

Evan Cook's ran a busy removal firm from their premises close to Queen's Road Station. The firm began in 1893 when Evan Cook (1865–1947) opened a secondhand furniture shop at 72 Queen's Road.

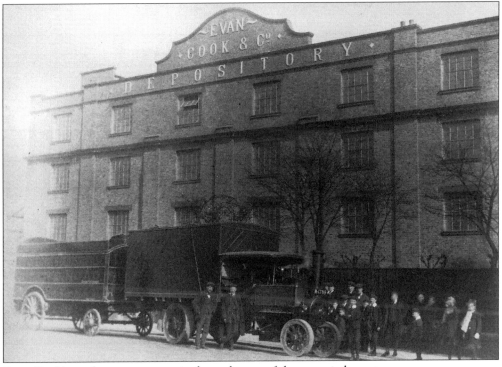

Evan Cook's used a steam wagon in the early part of the twentieth century.

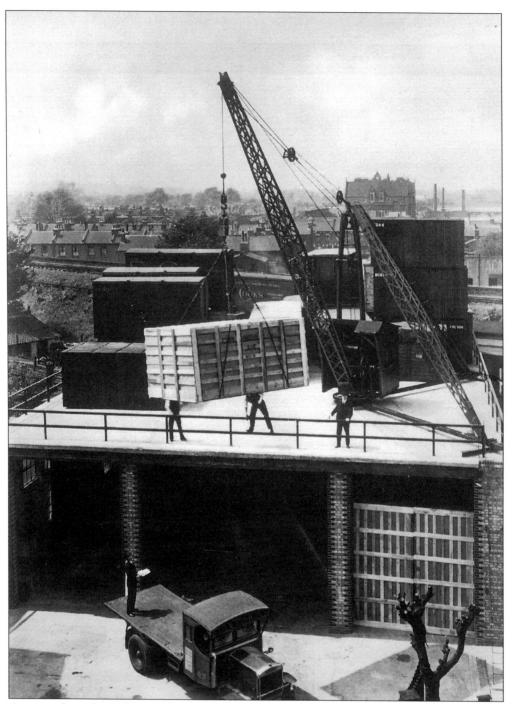

A crate is being loaded on to a lorry in Evan Cook's yard before the Second World War. Across the railway lines Wood's Road School can be seen. This end of the school was bombed and not rebuilt to the original design. This is the only pre-war picture of Wood's Road School known to exist.

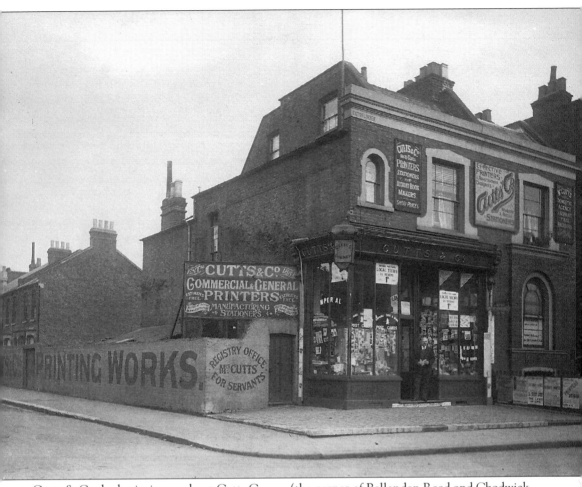

Cutts & Co. had printing works at Cutts Corner (the corner of Bellenden Road and Chadwick Road). The firm moved to these premises in 1894. Cutts & Co. closed down in 1990. Note the Registry Office (job agency) for servants run by Mrs Cutts.

Postmen assembled for this picture in the Hanover Street (now Highshore Road) Sorting Office in c. 1895. The present Royal Mail Delivery Office was built on the site and the front of the former Quaker Meeting House was incorporated into the new building.

Milk was sold for 6d a quart at the Lugard Road Dairy.

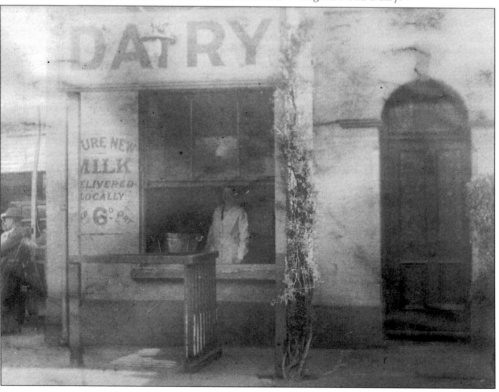

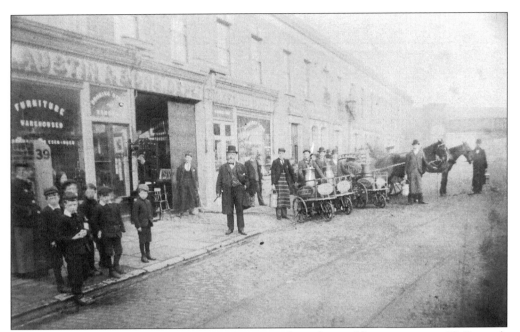

George Austin, founder of G. Austin & Sons, stands in front of his premises at 39 Brayards Road which he bought in 1878. Three perambulator-type milk floats and two horse-drawn milk carts are lined up in the road outside the Oxford Farm Dairy.

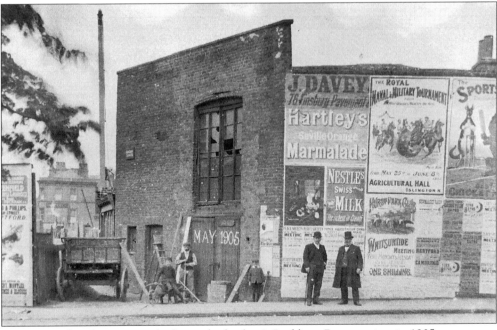

An Austin's handcart was parked outside the firm's Peckham Rye premises in 1905.

A plaque-laying ceremony was held in Tilling's Bull Yard engineering works. In 1905 the premises were converted into a garage for 35 buses.

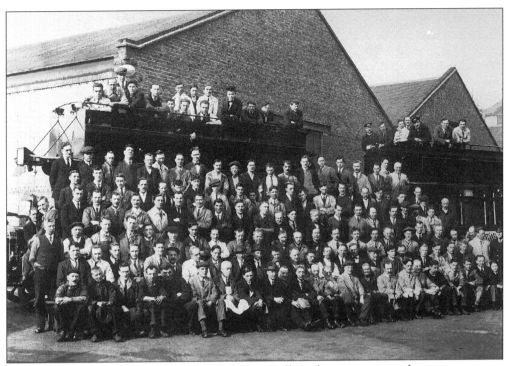

Thomas Tilling Ltd. employed many men at their Bull Yard engineering works.

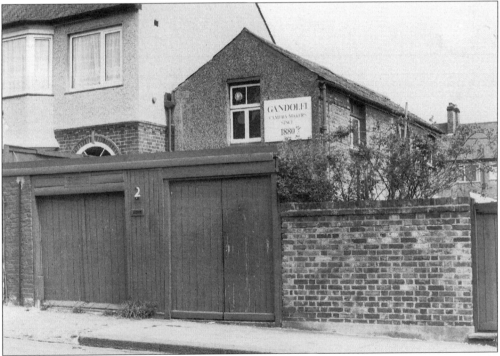

Cameramakers Gandolfi had their workshop in Borland Road. The centenary of the Gandolfi enterprise was marked by a special exhibition at the Science Museum in 1980. Two Gandolfi cameras, which are wooden and handmade, are in the Cuming Museum.

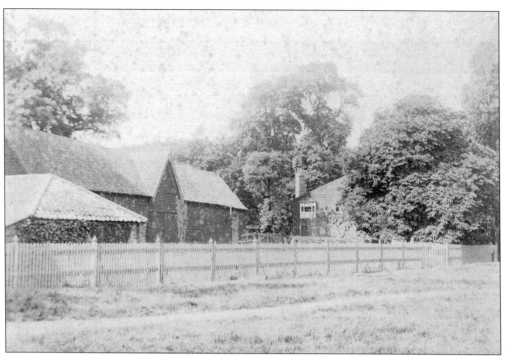

Homestall Farm occupied a site in Peckham Rye Park close to where the bowling green is today.

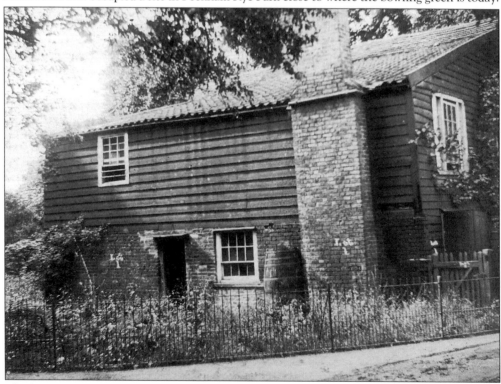

The house in Homestall Farm was demolished in August 1908 so Peckham Rye Park could be extended.

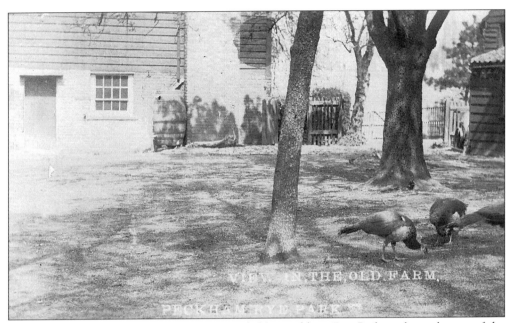

A small part of Homestall Farm was surrounded by Peckham Rye Park in the early part of the twentieth century.

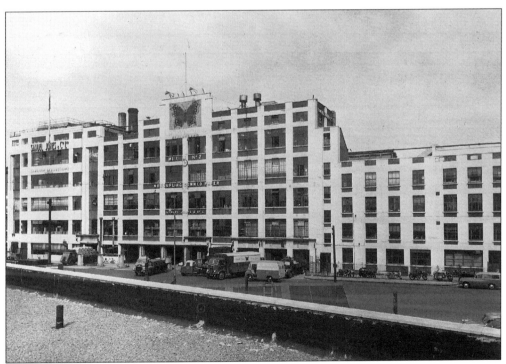

The gummed paper factory of Samuel Jones & Co. Ltd stood in Peckham Grove.

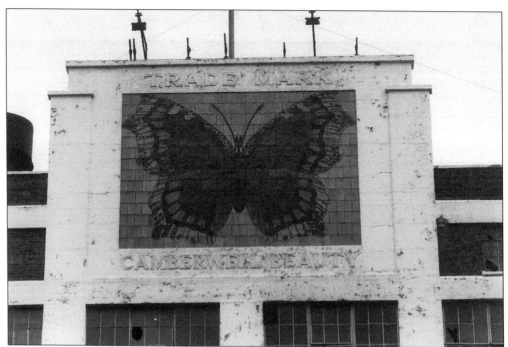

In 1980 the trademark of Samuel Jones & Co. Ltd was still at the top of its factory. After the factory was demolished, the butterfly was transferred in 1982 to the outside wall of the old public baths and laundry in Wells Way. The gummed paper firm adopted the Camberwell Beauty as its trademark in 1912. The butterfly was first recorded in England in 1748 when two specimens were captured in what is now Coldharbour Lane in Camberwell.

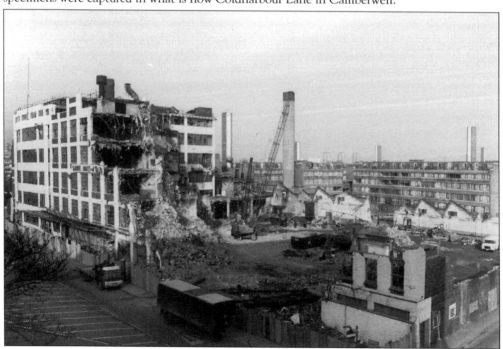

Samuel Jones' gummed paper factory was demolished in 1982.

Five

Transport

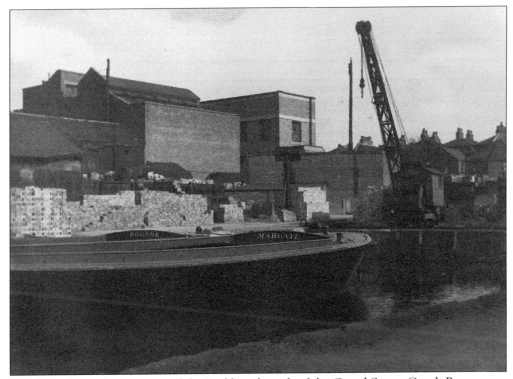

Canal Head was the terminus of the Peckham branch of the Grand Surrey Canal. Barges were used for transporting bricks, wood, and other building materials.

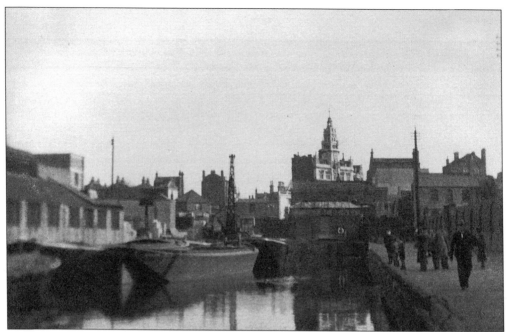

Canal Head in c. 1930 looked very different from the grassed area behind Peckham Square which was opened in 1994. The tower of Jones & Higgins' store is in the background. The Peckham branch of the Grand Surrey Canal was completed in 1826, linking Peckham village with the River Thames. The canal was filled in during 1972 and is now a linear park leading to Burgess Park.

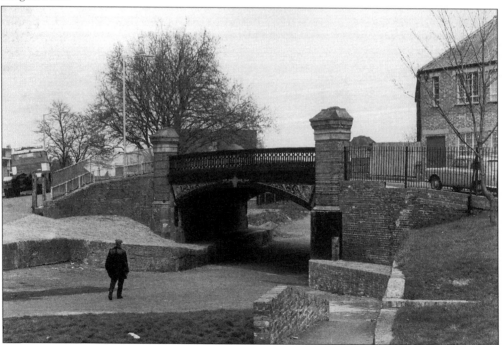

Willowbrook Bridge was photographed in 1979 soon after it had been painted. The Peckham branch of the Grand Surrey Canal used to flow beneath the bridge.

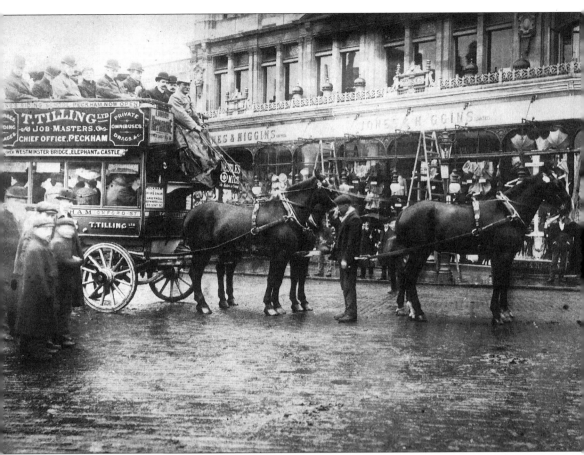

Tilling's omnibus is seen outside Jones & Higgins' store at the junction of Rye Lane and the High Street.

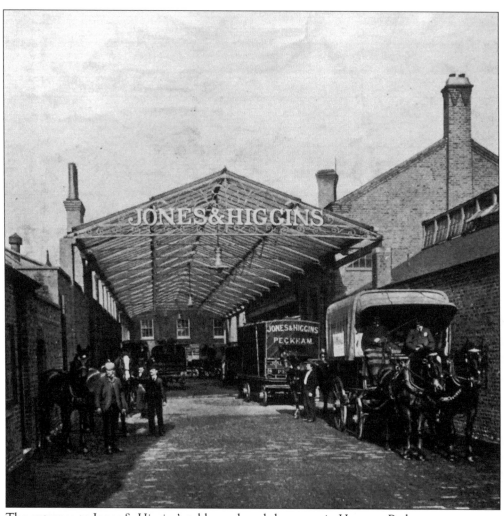

The entrance to Jones & Higgins' stables and workshops was in Hanover Park.

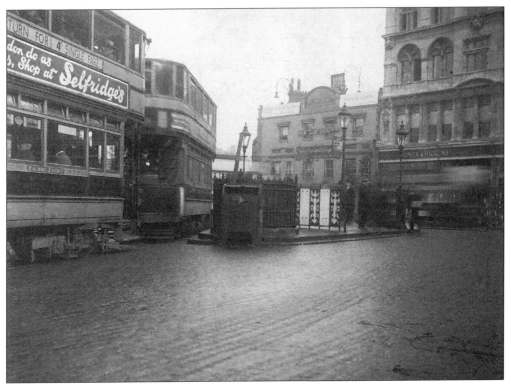

Trams stopped near the public conveniences at the junction of Rye Lane and the High Street.

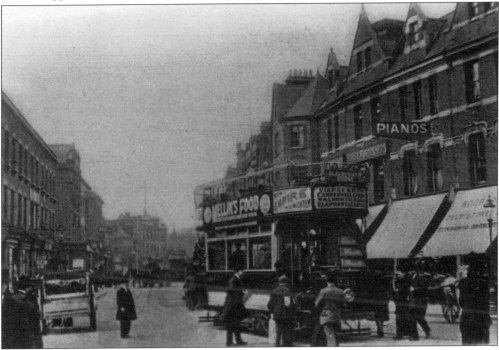

People had to walk to the centre of the High Street to board an electric tram to Blackfriars Bridge.

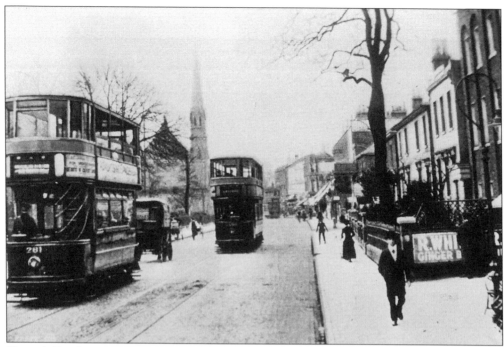

Queen's Road was a tram route to New Cross as this 1911 view shows. Peckham Wesleyan Church, opened in 1865, is in the background.

Horse-drawn vehicles dominated the scene at Peckham Rye in c. 1915. Peckham Rye Tabernacle, which opened in 1891, is on the left.

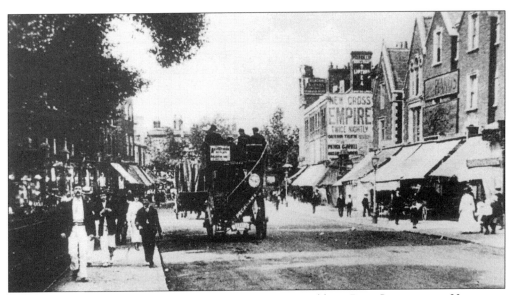

A horse-drawn omnibus heads towards Rye Lane from Peckham Rye. Co-operative House was built on the site of the building which advertises the New Cross Empire.

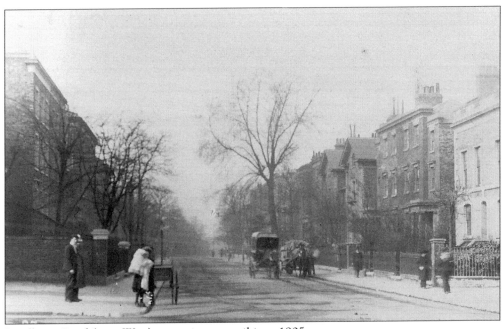

Lyndhurst Road (now Way) was quite tranquil in c. 1905.

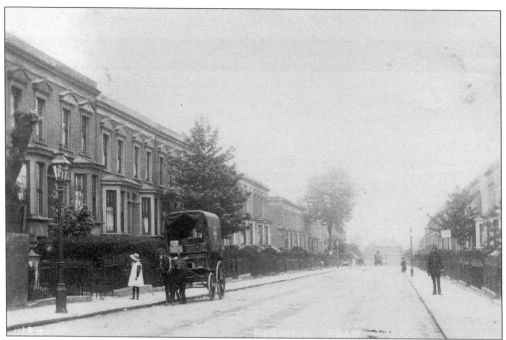

Fenwick Road was quiet in *c.* 1905. Note the bearded policeman on the right side pavement with a TO LET sign behind him.

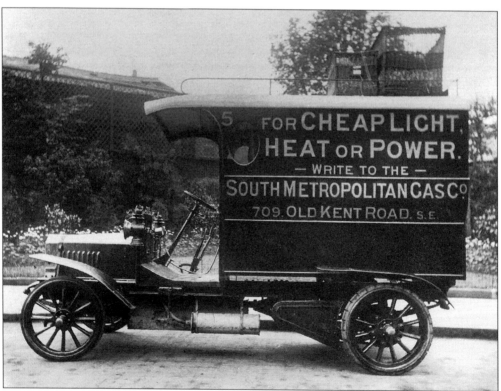

When this motor van was used in *c.* 1910 many Peckham homes were lit by coal gas.

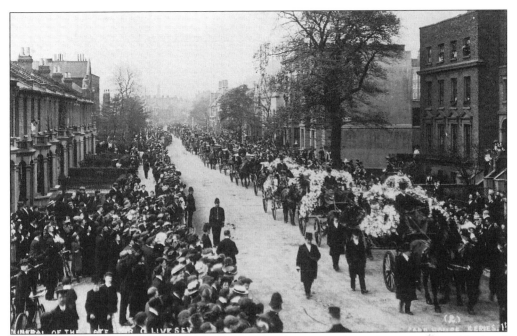

Sir George Livesey's funeral in 1908 attracted a large crowd on the journey to Nunhead Cemetery. George Livesey started working for the South Metropolitan Gas Company in 1848. He became chairman of the board of directors in 1885.

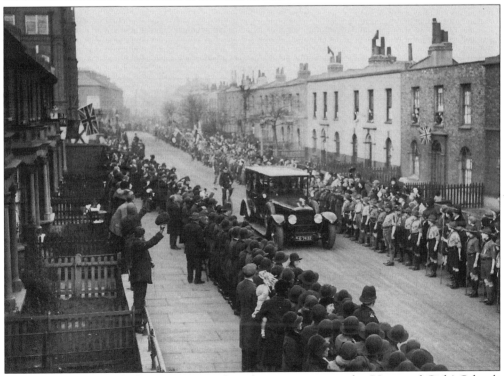

Queen Mary travelled along Friary Road on her way to open the Union of Girls' Schools Settlement (now the Peckham Settlement) in 1931.

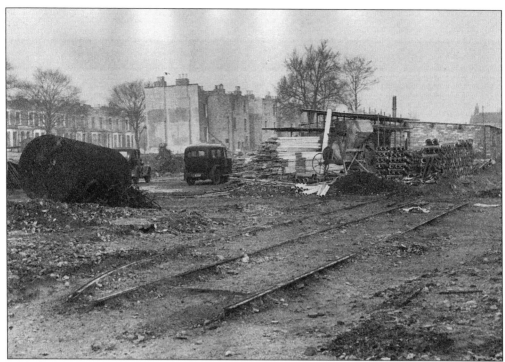

Rails from a former horse tram depot in East Dulwich Road were unearthed in January 1953. The trams were run by the London, Camberwell & Dulwich Tramways Company. Fenwick Road is on the left.

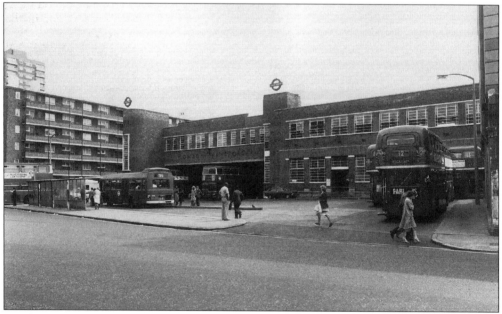

London Transport's bus garage dominated Peckham High Street in 1979. This was opened in 1951 and was designed by Wallis Gilbert & Partners who designed the Firestone building at Brentford and the Hoover building at Perivale. The garage was demolished in 1995-6 to make way for an extension to the Safeway store in the Aylesham Centre.

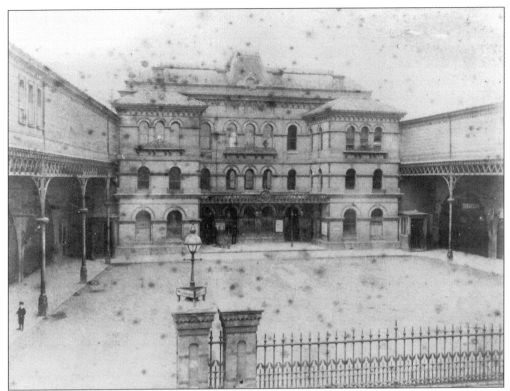

Peckham Rye Station was opened on 1 December 1865 though the date of this picture is unknown. The station was named Peckham Rye to distinguish it from Peckham Station (later renamed Queen's Road, Peckham). This picture was taken before shops were built in the forecourt. The sign on the left below the lamp pointed to the telegraph office.

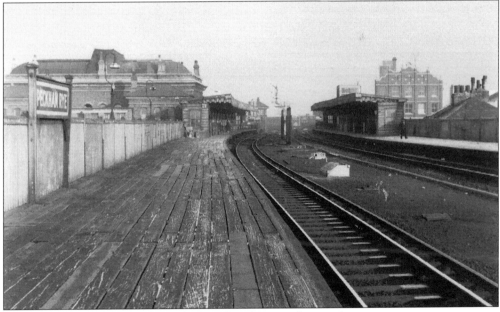

Peckham Rye Station was deserted when this photograph was taken.

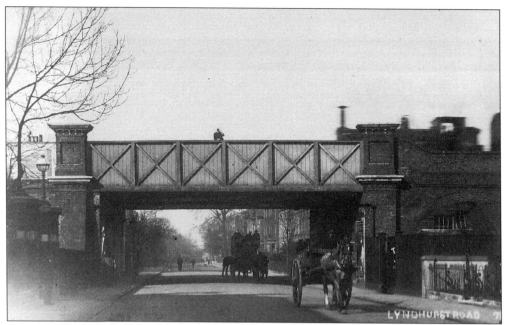

A steam train crosses the Lyndhurst Road railway bridge in c. 1905.

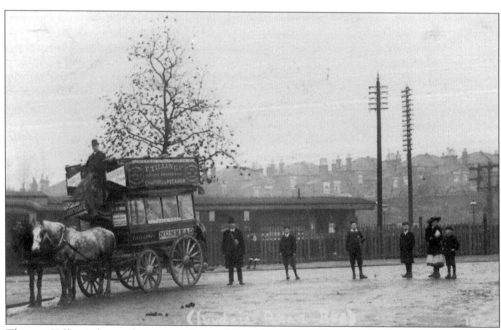

Thomas Tilling's horse-drawn omnibus collected passengers from Nunhead Railway Station in c. 1905.

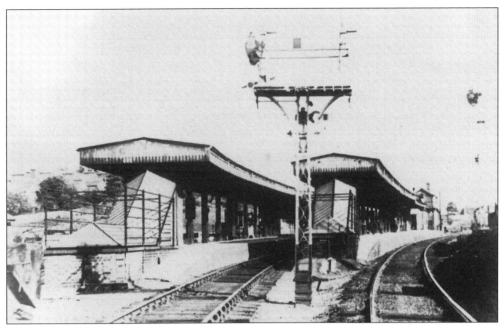

Nunhead Station had a signal box at the end of a platform in *c.* 1920.

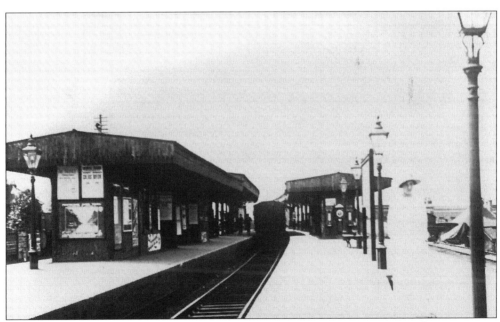

Nunhead Railway Station in *c.* 1920 had a weighing machine for passengers. The station was closed on 3 May 1925 and resited on the other side of Gibbon Road.

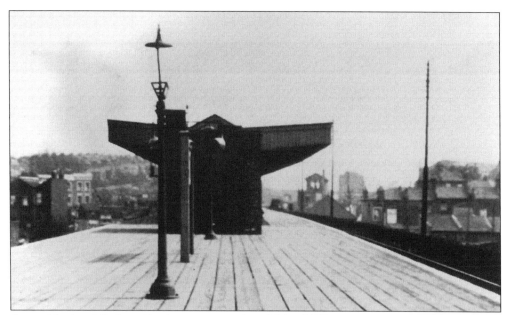

A new Nunhead Railway Station was opened on 3 May 1925.

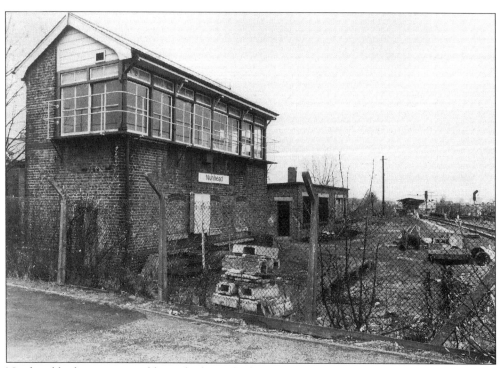

Nunhead had its own signal box which was built in 1925 and ceased to function on 17 January 1982.

Six

Education and Leisure

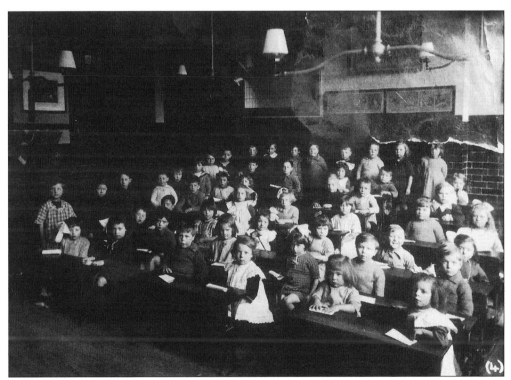

In 1924 infants in Leo Street School, Asylum Road, sat at double wooden desks which were commonly used in the first half of the twentieth century.

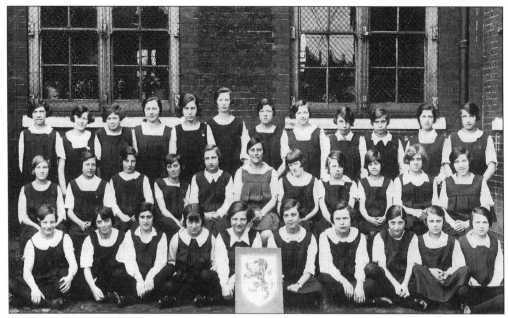

Peckham Central School's form 3 looked smart in their gymslips in 1927. The school was in Choumert Road.

David Sheppard, when he was Bishop of Woolwich, opened Tuke School in Harder's Road (now Wood's Road) on 8 June 1970. The ceremony was watched by the Mayor of Southwark, Councillor N.H. Tertis.

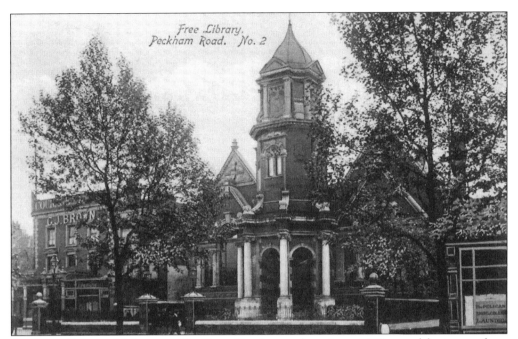

Free Library.
Peckham Road. No. 2

Camberwell Central Library in Peckham Road, seen here in *c.* 1905, stood between where the former Walmer Castle public house and Pelican House are today. Kingfisher House now occupies the site of the library which was opened in 1893.

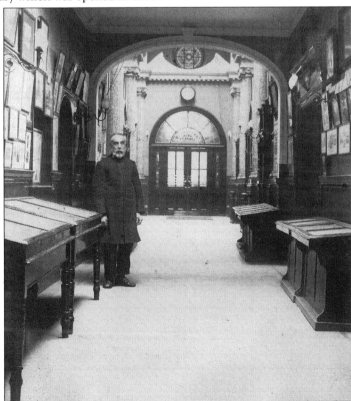

A member of the Camberwell Central Library staff stands in the entrance hall.

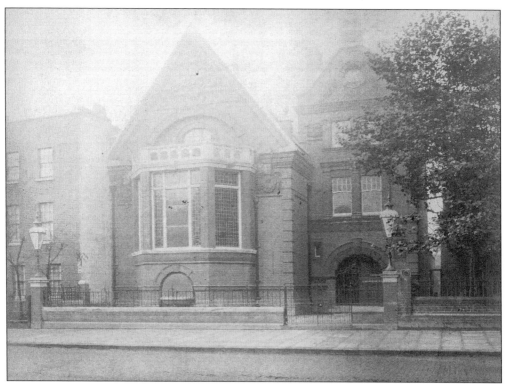

Livesey Library, in the Old Kent Road, was opened on 18 October 1890. The donor of the library, George Livesey, was chairman of the board of directors of the South Metropolitan Gas Company. He was knighted in 1902.

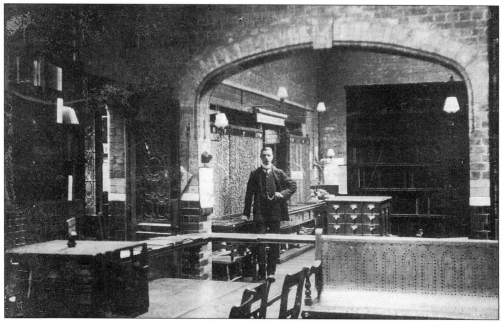

The adult lending library department of Livesey Library (later the Livesey Museum) in the Old Kent Road was photographed in c. 1905.

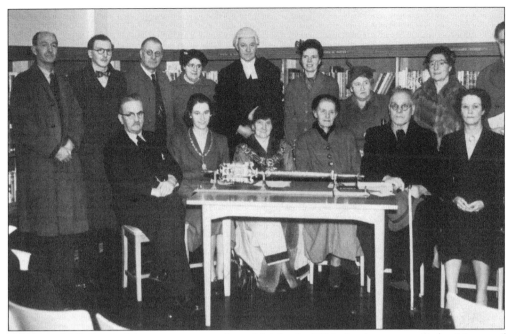

Peckham Hill Street Library was opened on 20 March 1954. In the centre is the Mayor of Camberwell, Councillor Rosina Whyatt, who performed the opening ceremony. Freda Corbet, M.P. for Peckham, sits on the Mayor's left. Mr W. Hahn, Borough Librarian for Camberwell, is seated at the extreme left.

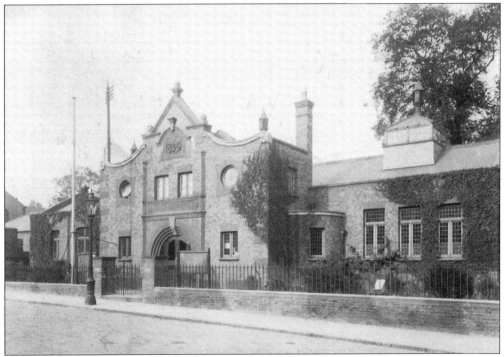

Nunhead Public Library was opened in 1896. It was the gift of editor and philanthropist John Passmore Edwards (1823–1911) who laid the foundation stone on 11 April 1896.

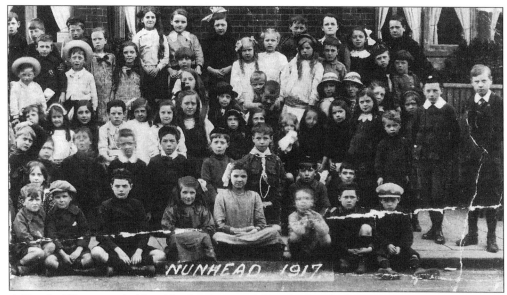

A Band of Hope was held in Nunhead in *c*. 1917. The Band of Hope was a popular national organisation which taught children about the dangers of drink and encouraged Christian citizenship. Hope UK, a national drug education charity, is the successor organization to the United Kingdom Band of Hope Union.

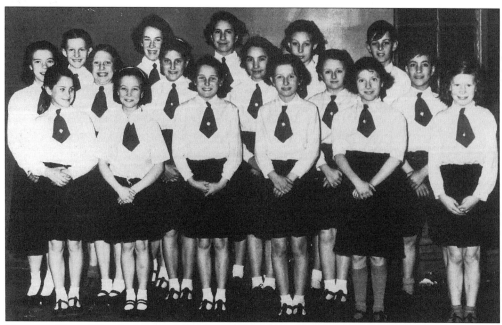

Hanover Chapel Band of Hope had a choir in the early 1950s.

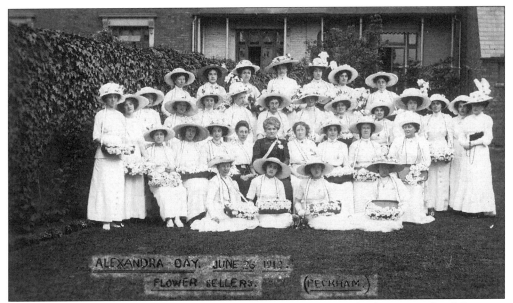

Flower sellers were photographed on 26 June 1912, the day on which a great Floral Fête was inaugurated. From the following year this became the annual Alexandra Rose Day to mark the 50th anniversary of Queen Alexandra's first landing in the British Isles. Flowers were sold to raise funds for hospitals and other charitable organisations.

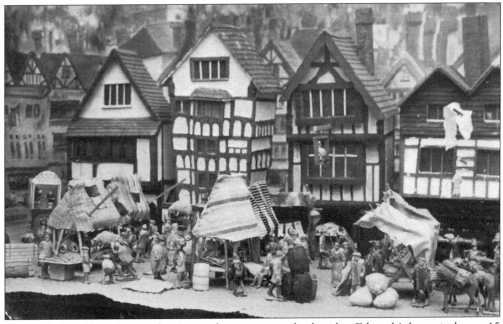

A model of Peckham Fair in the sixteenth century was displayed in Edwards' shop window at 15 High Street on 3 September 1904. The fair extended from Peckham House (where The Harris Academy at Peckham is today) to Meeting House Lane. It took place for three days from 22 August and was last held in 1826.

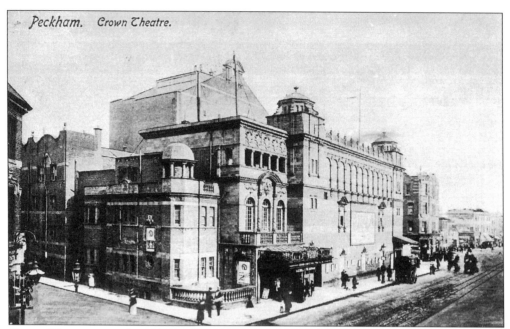

Crown Theatre opened on 31 October 1898 and dominated the High Street.

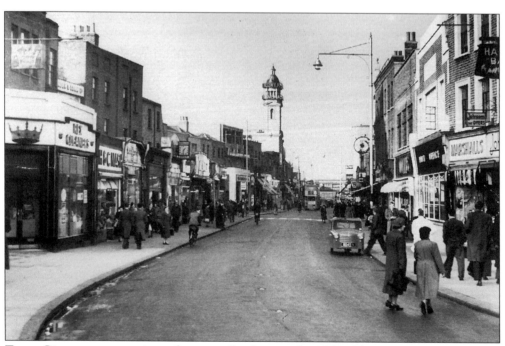

Tower Cinema was a prominent feature in Rye Lane in the 1950s. The cinema opened in 1914 and closed on 1 December 1956.

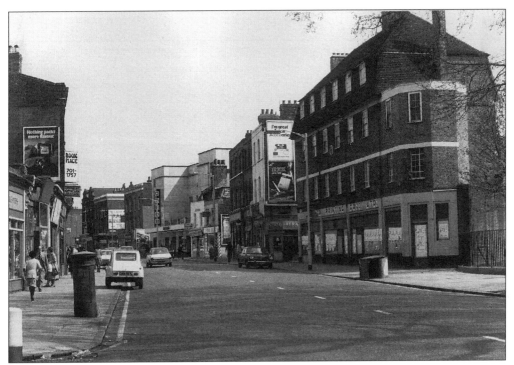

Odeon cinema existed in Peckham High Street in 1979.

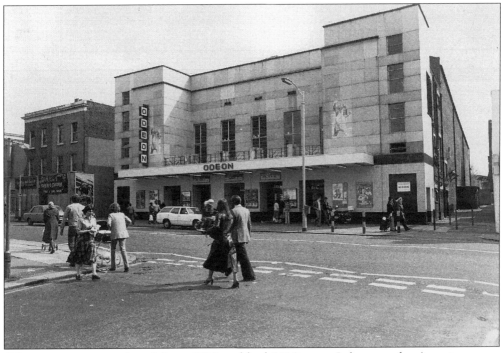

Odeon cinema opened on 1 June 1938 and had 2110 seats. It became the Ace cinema on 1 November 1981 and closed on 1 December 1983. The building was demolished and a Benefits Agency Office opened on the site on 21 March 1994.

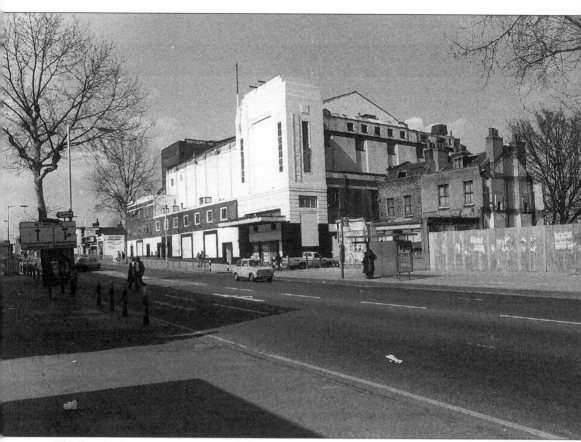

The former Astoria cinema was a prominent feature in the Old Kent Road in 1980. It closed in 1968 but was not demolished until 1984.

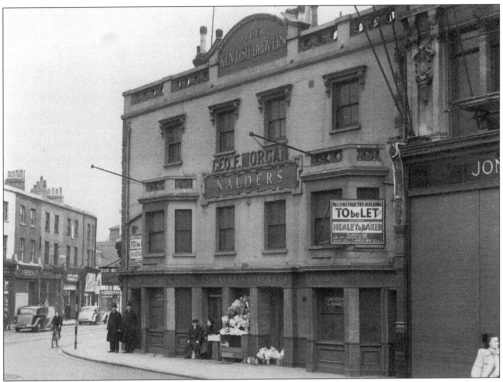

Kentish Drovers next to Jones & Higgins was a pub from the eighteenth century until 1954 when it was converted into a shop.

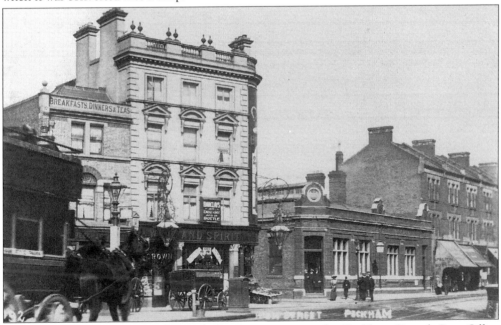

The Crown public house in the High Street was next to the Peckham Branch Post Office in c. 1905. A new Post Office was built on the site after the old one was bombed during the Second World War.

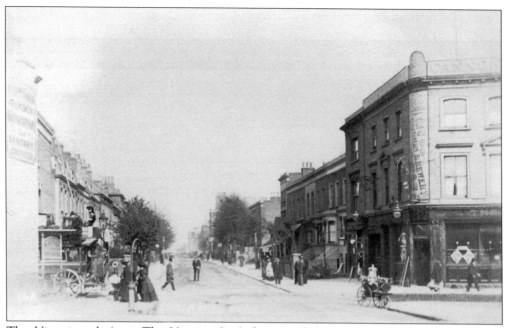

The Victoria pub (now The Victoria Inn) dominated the corner of Victoria Road (now Bellenden Road) and Choumert Road in c. 1905. Note Thomas Tilling's omnibus on the left and a milkcart on the right.

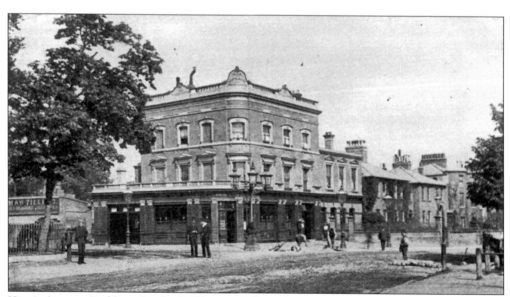

King's Arms at Peckham Rye had a Thomas Tilling depot next to it in East Dulwich Road in c. 1909. German bombers over London in 1940 scored a direct hit on the pub and eleven people were killed.

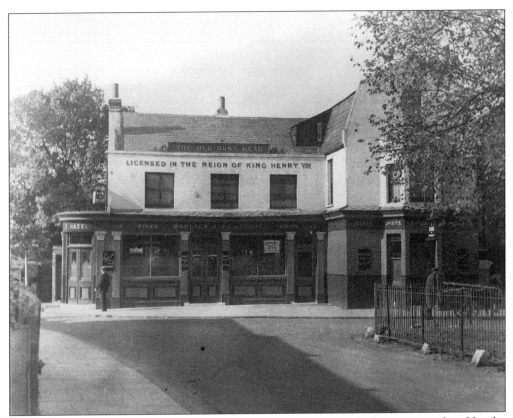

The Old Nun's Head, Nunhead Green, was photographed shortly before it was replaced by the present pub in 1934.

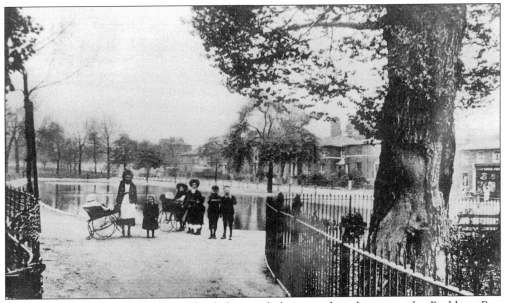

Mothers and children with large-wheeled perambulators gathered next to the Peckham Rye lake.

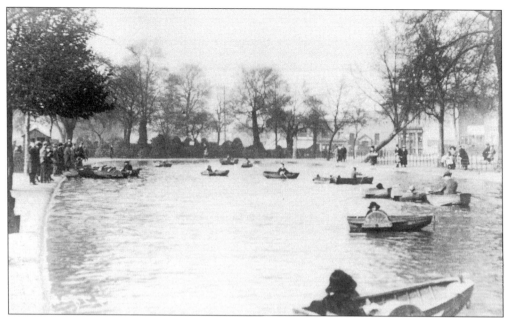

Boats were a popular attraction on the Peckham Rye lake in the early part of the twentieth century. The lake was filled in during 1953. In the background is Austin's with Scylla Hall on the right.

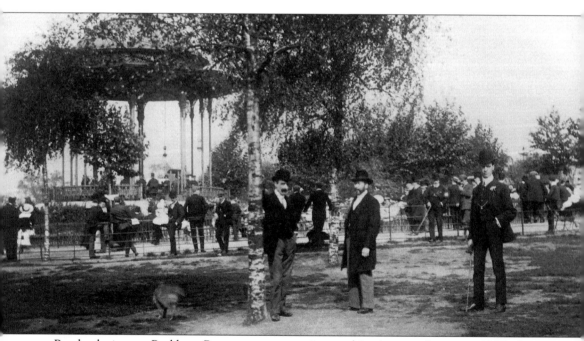

Bands playing on Peckham Rye were an attraction as this picture, taken in c. 1905, shows. The bandstand was moved from the Royal Horticultural Society's Garden in Kensington and opened on Peckham Rye on 11 July 1889 by the Earl of Meath, chairman of the Parks and Open Spaces Committee of the London County Council. The bandstand was demolished during the Second World War after being damaged by a landmine.

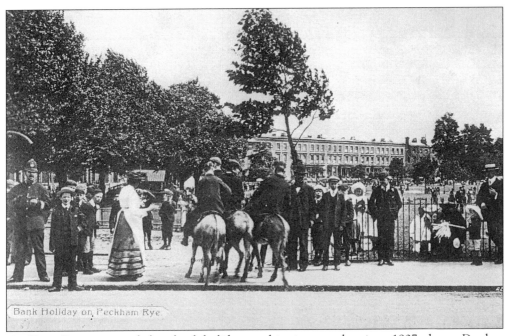

Peckham Rye was crowded on bank holidays as this picture, taken in c. 1907, shows. Donkey rides were a popular attraction.

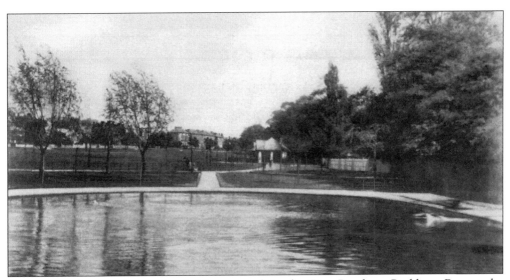

Dogs enjoyed swimming and splashing around in the Dog Pond on Peckham Rye at the beginning of the twentieth century.

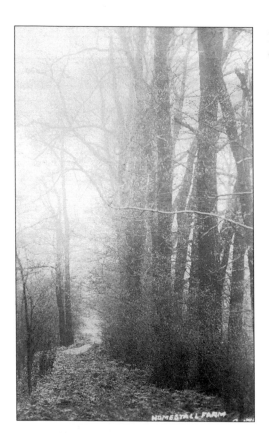

Homestall Farm was featured in a postcard in *c.* 1900. Some of these trees may still exist in Peckham Rye Park.

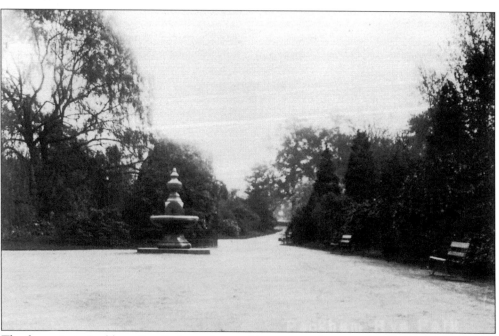

The fountain in Peckham Rye Park was featured in a postcard sent in 1914. The fountain was provided by Edwin Jones, co-founder of Jones & Higgins, and unveiled on 1 July 1897.

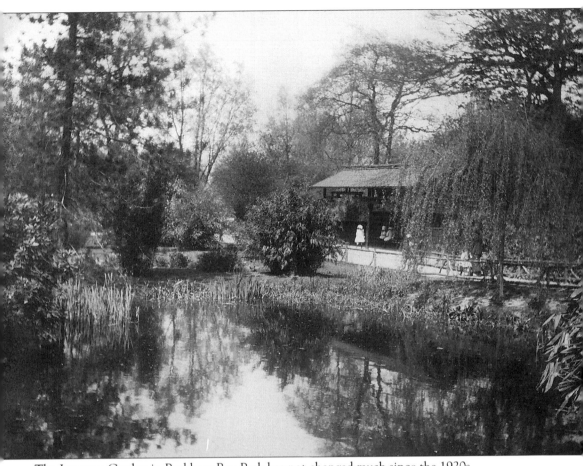

The Japanese Garden in Peckham Rye Park has not changed much since the 1920s.

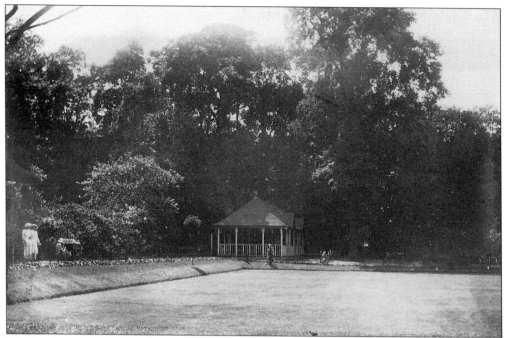

The bowling green in Peckham Rye Park, seen here in the 1920s, was provided by the London County Council. It was created after the remaining part of Homestall Farm was absorbed into the park.

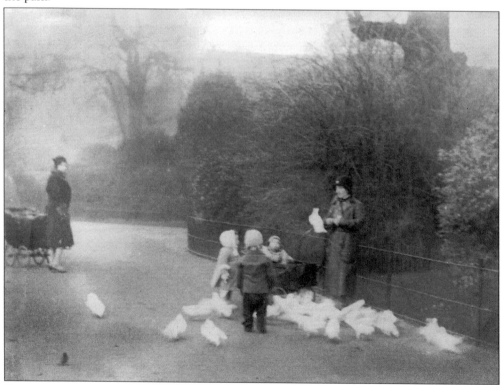

Doves were an attraction in Peckham Rye Park in 1935.

Seven

Churches

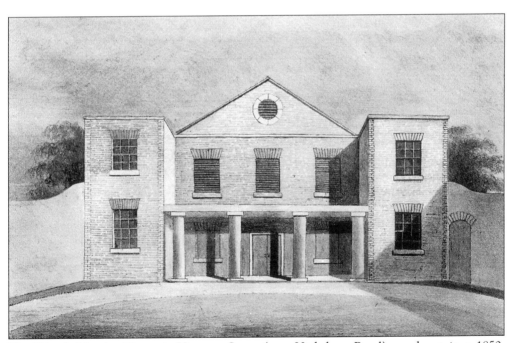

The Friends Meeting House in Hanover Street (now Highshore Road) was drawn in *c.* 1850. The front of the Royal Mail Delivery Office is the original entrance to the former Meeting House opened in 1826.

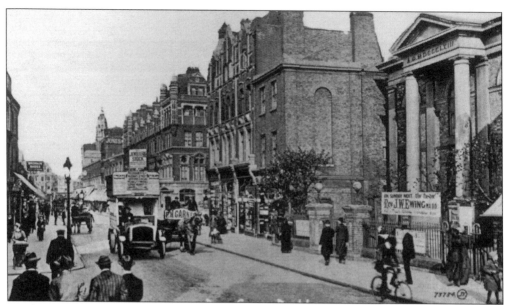

Revd Dr John W. Ewing was pastor of Rye Lane Chapel when it was featured in a postcard in *c.* 1905. The chapel was opened in 1863. It was typical of the Baptists in being Classical when most denominations were using Gothic.

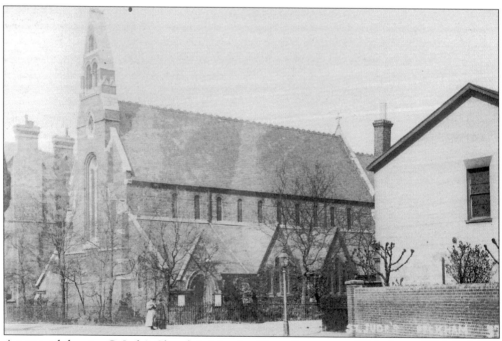

A postcard showing St Jude's Church in Meeting House Lane was published in *c.* 1905. St John's was built on the site.

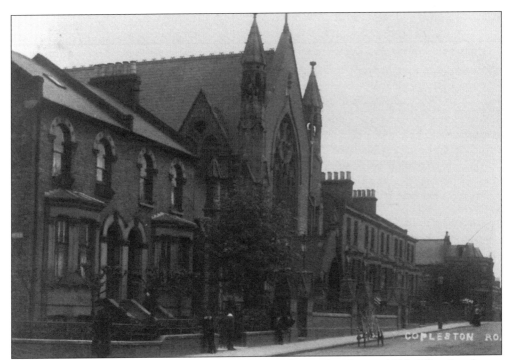

St Saviour's Church was a prominent feature in Copleston Road in c. 1905. The church was consecrated in 1881. It was remodelled in the 1970s and is now known as the Copleston Centre. This is used for worship by the St Saviour's and Hanover United Reformed Church congregations. The latter is the oldest surviving non-Anglican congregation in Peckham, with a history going back to the middle of the seventeenth century.

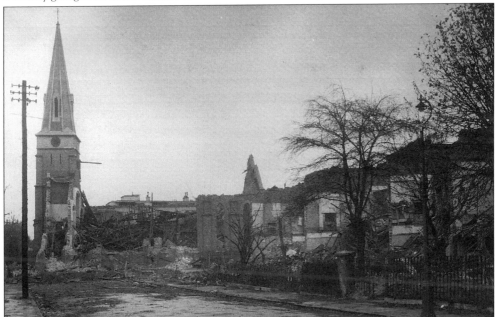

St Mary Magdalene Church was destroyed by a landmine on 21 September 1940. It was consecrated by the Bishop of Winchester on 7 May 1841.

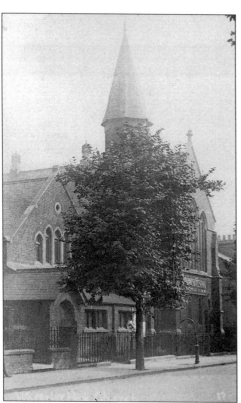

Waverley Park Church in Ivydale Road was opened on 30 May 1896 by Mrs Evan Spicer, the wife of a London County Councillor. This was the last Methodist New Connexion church to be built in London. The building was taken over by Peckham Seventh Day Adventist Church in 1986.

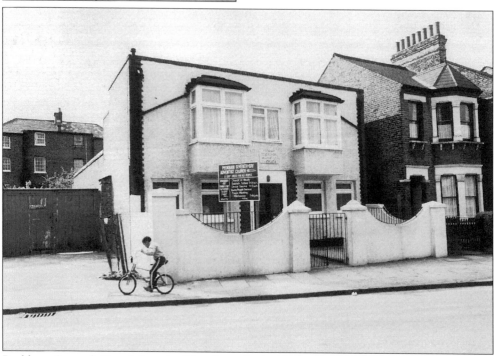

Peckham Seventh Day Adventist Church used a building at 86 Bellenden Road in 1981. This is now Elim House, the base of the Black Elderly Group Southwark.

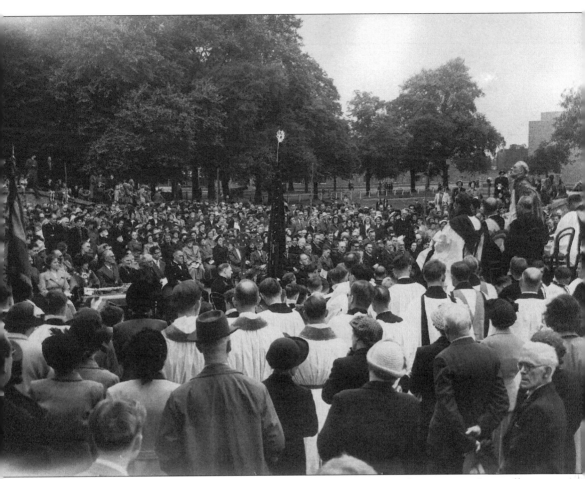

An open-air service was held on Peckham Rye in 1953. The Mayor in the picture is Councillor Mrs Rosina Whyatt.

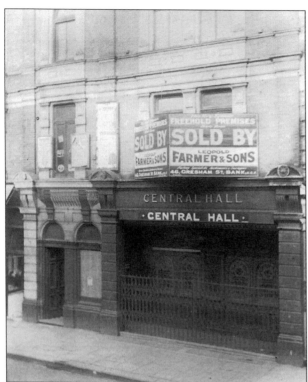

The Central Hall at 43 High Street was sold in 1935. The Revd G. Ernest Thorn was minister of the Church of the Strangers which used the Central Hall from 1908 until 1932. Mr Thorn dressed in a suit of armour when he preached on 'Put on the whole armour of God'.

This hall, which was used by Hanover Chapel Sunday School, stood in Danby Street. The hall was erected in 1877 and was destroyed by arson in 1993. The foundation stone of a new hall was laid by Bishop Pitt on 18 November 1994.

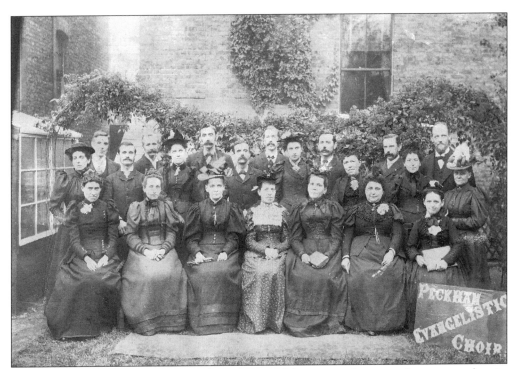

Peckham Evangelistic Choir sang in the early part of the twentieth century but no records exist of the choir's performances.

The former Corpus Christi College Cambridge Mission in Ilderton Road was opened in 1890. The church closed in 1962.

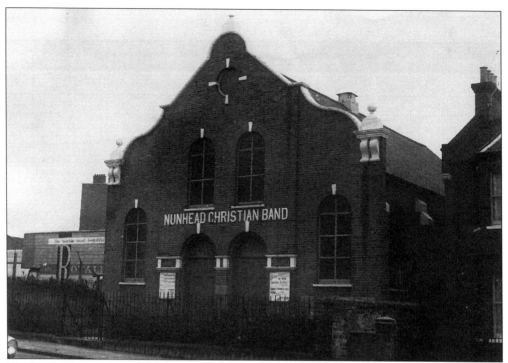

Nunhead Christian Band in Nunhead Grove conducted services and ran various activities in c. 1972. The building was opened in 1902.

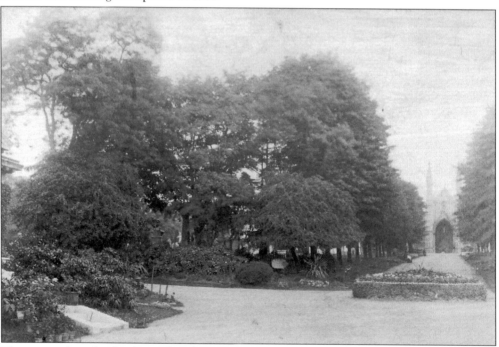

The approach to the Anglican chapel in Nunhead Cemetery was photographed in c. 1895. The cemetery was opened in 1840. The Anglican chapel was badly damaged in an arson attack in 1974.

Eight

Public Services

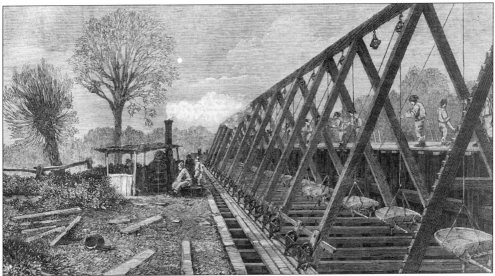

This 1861 picture shows a barrow-hoist on the southern high-level sewer. This was part of the Metropolitan Board of Works' Main Drainage scheme for London, planned by Sir Joseph Bazalgette. As Peckham grew in the second half of the nineteenth century, open sewers were replaced by underground sewers.

Camberwell Workhouse in Gordon Road, known as 'The Spike', had a chapel. This was demolished in 1993.

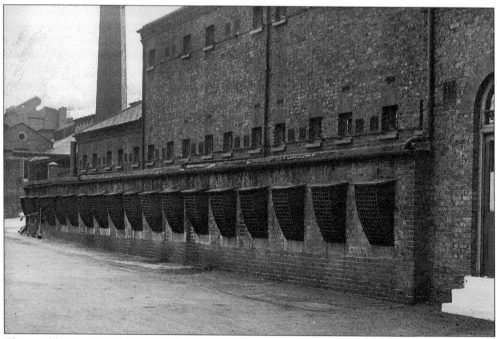

The workhouse in Gordon Road had seventeen grilles on a wall. Poor people paid for a night's lodging by sitting in cells and breaking stones small enough to pass through the grille. The stones were used to fill holes in the roads. One grille is preserved in the former Livesey Museum in the Old Kent Road.

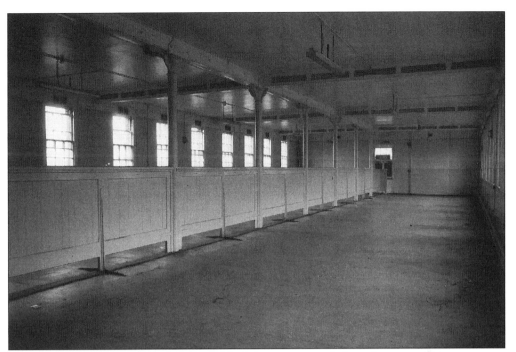

Camberwell Workhouse in Gordon Road had dormitories including this one.

A Relief Station (i.e. casual ward for Camberwell Board of Guardians), opened in 1901 in Consort Road, was a London County Council Welfare Clinic in 1953.

New street lighting was installed in McDermott Road in *c.* 1936.

In the 1930s electric lighting was installed above a horse trough in Evelina Road.

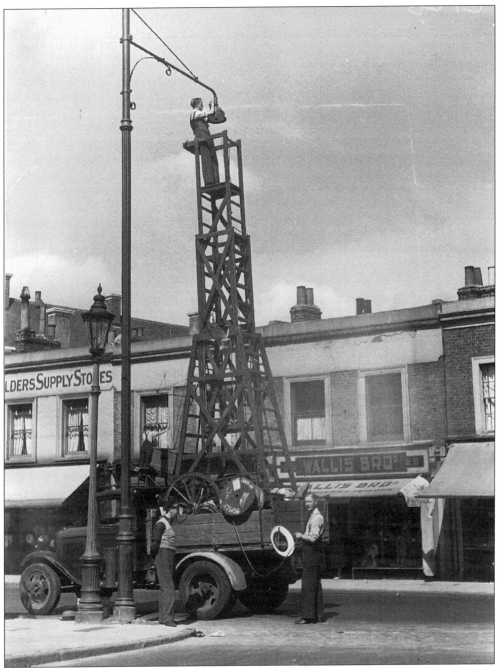

A lantern in Nunhead Lane was fixed in *c.* 1935. The outer glass refracting bowl, which distributed light from the Osira Lamp, was fitted afterwards.

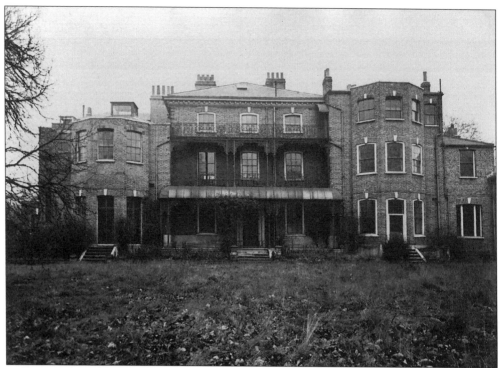

Peckham House was photographed shortly before it was demolished in 1954 to make way for Peckham School (where The Harris Academy at Peckham is today). Originally the home of the wealthy Spitta family, Peckham House became a private mental hospital.

The drive leading to Peckham House is seen here in c. 1935.

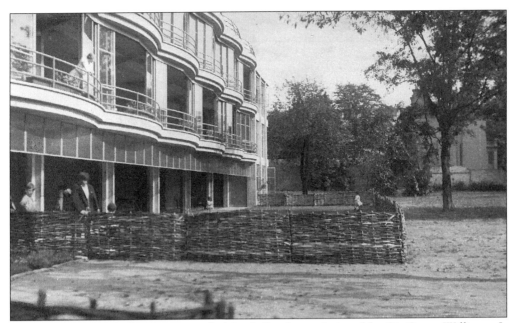

Peckham Pioneer Health Centre in St Mary's Road was designed by Sir Owen Williams. It was opened in May 1935. The notable Peckham Experiment was begun by Dr George Scott Williamson and Dr Innes Pearse in 1926 at 142 Queen's Road. The world-famous scientific investigation into the nature and cultivation of health continued until 1950.

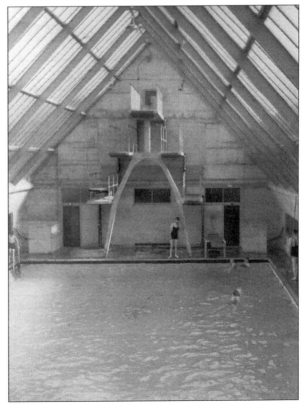

The swimming pool in the Peckham Pioneer Health Centre was a popular feature of the specially designed building. In his book on London, Arthur Mee wrote: 'One of the most interesting of all Peckham's buildings is its remarkable Health Centre. It is a great club house for the families of Peckham, where they find every encouragement known to science to be healthy and happy, and wise. Here they may dance, fence, play games, enjoy physical exercises and swim in a beautiful blue-green bath. There is a children's bathing pool with a playground, a library, a cafeteria, a kitchen, a hall and a running-track. In setting up this great Health Centre Peckham has set a fine example to the densely peopled areas of our great cities. The West End of London has nothing to equal it.'

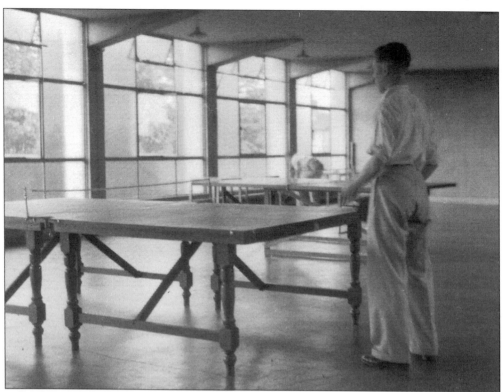

Table tennis was played in the games room of the Peckham Pioneer Health Centre.

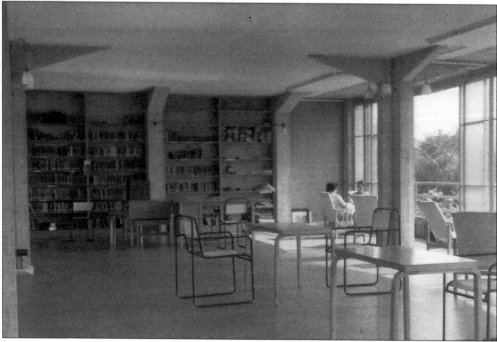

The library of the Pioneer Health Centre was used by local families who took part in this important health experiment.

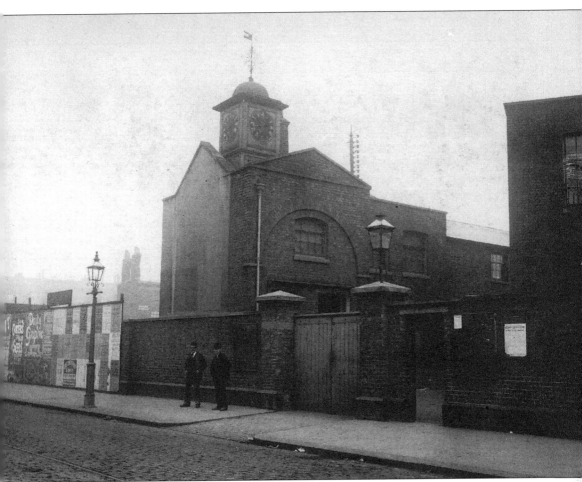

The police station, seen here in *c.* 1890, stood in the High Street on the site of the present building. The property, known as 'The Clock House', was leased in 1847 from Henry Thomas Perkins to be used for police purposes.

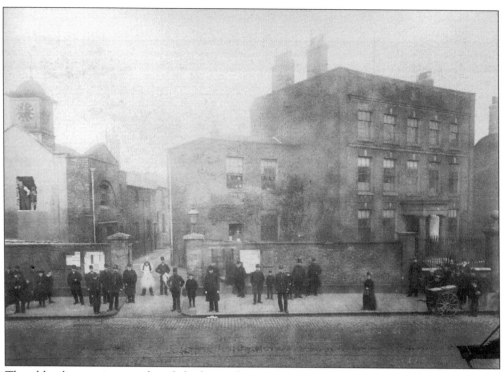

The old police station was demolished to make way for a new station opened in 1893.

Peckham Police Station is seen here in c. 1905. Crown Theatre is in the background.

Nine

War and Peace

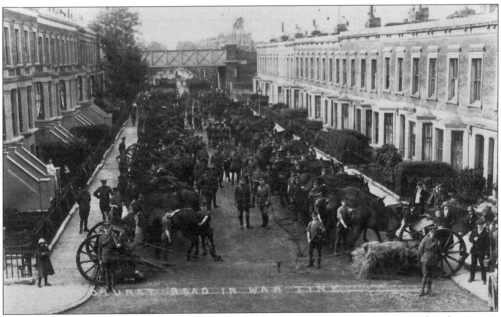

In 1915 army horses were tethered in Lyndhurst Road (now Way) to avoid infection in temporary stables at Gordon's brewery, 120 Lyndhurst Road.

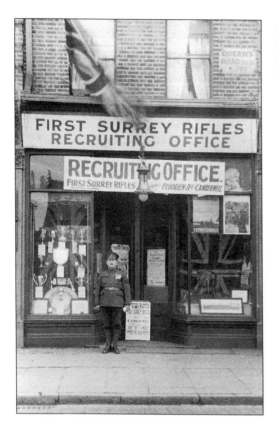

Sgt Matthews stands outside the First Surrey Rifles Recruiting Office at 31 and 33 Queen's Road in *c.* 1928. The First Surrey Rifles was formed in 1859.

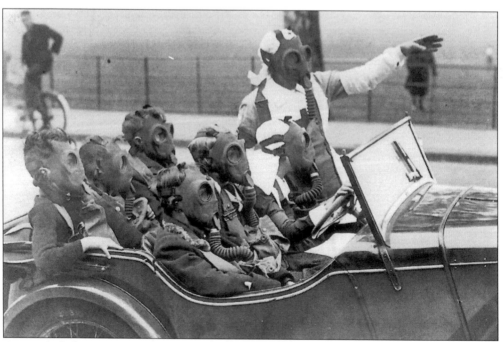

Gas mask drill was practised outside the Red Cross headquarters facing Peckham Rye.

Jones & Higgins' premises in Hanover Park were damaged in January 1943 in a German raid on London.

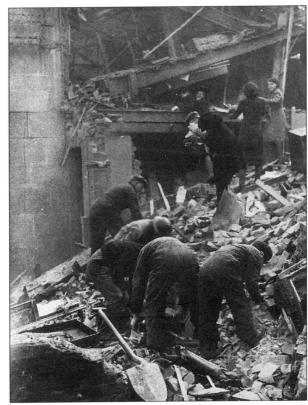

Rescue workers searched through debris in East Surrey Grove on 17 May 1943.

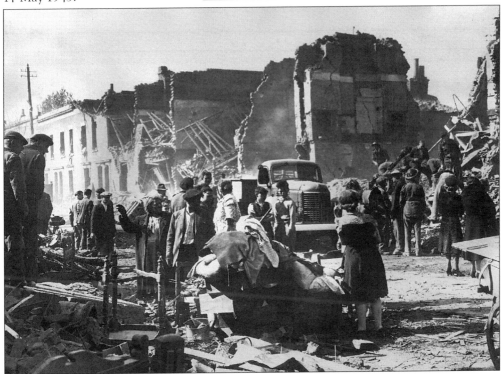

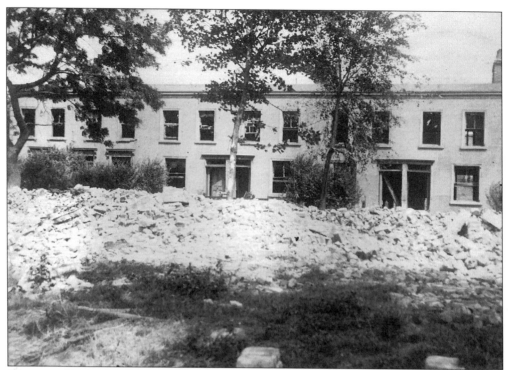

Maismore Terrace in Maismore Street was photographed on 23 July 1945 showing damage caused during the Second World War.

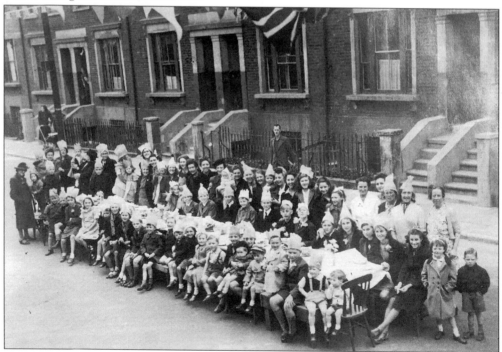

A street party was held in Marmont Road in 1945 to celebrate the end of the Second World War.

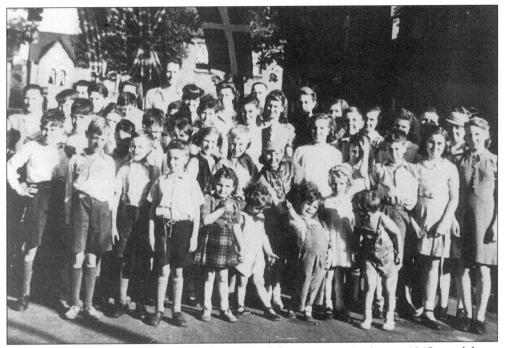
Children and adults assembled in Everthorpe Road during a party in August 1945 to celebrate VJ Day. Oglander Road is in the background.

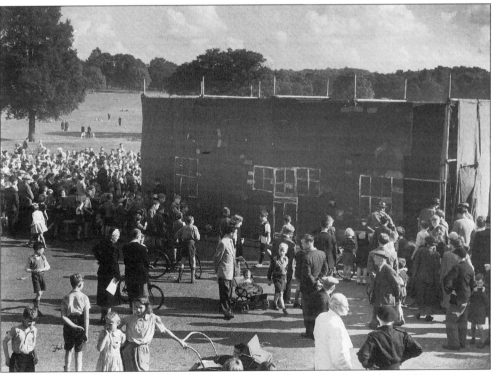
A Civil Defence demonstration was held on Peckham Rye on 26 September 1953.

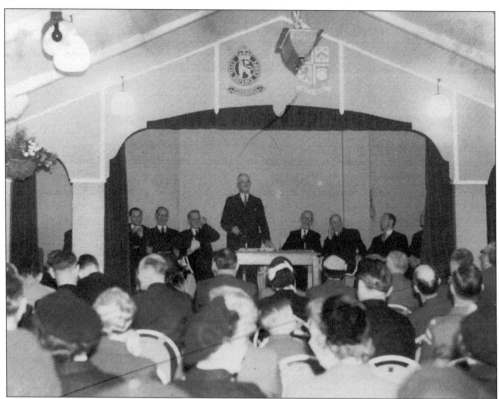

The Rt Hon. J. Chuter Ede, MP opened the Kirkwood Training Centre (for Civil Defence) on 9 October 1954. It stood at the corner of Kirkwood Road and Brayards Road.

Acknowledgements

Most of the photographs were loaned by Southwark Local History Library. This valuable library, with its knowledgeable and helpful staff, is based at 211 Borough High Street, SE1 1JA (Tel: 020 7525 0232). I am very grateful for the co-operation and assistance of Janice Brooker, Stephen Humphrey and Stephen Potter.

Thanks also go to local people who provided photographs: Clive Atkinson, Derek Austin, Elsie Bonson, Lilian Burden (née Tandy), Tim Charlesworth, Bernard Evan Cook, John Dell, Muriel Demwell (née Buckle), Steve Hume, Ann Ward and Joan Young (née Foster).